D1344155

In Focus
Photographs from the J. Paul Getty Museum
Weston Naef, *General Editor*

The J. Paul Getty Trust
1200 Getty Center Drive
Suite 400
Los Angeles, California 90049-1681

Christopher Hudson, *Publisher*
Mark Greenberg, *Managing Editor*

Library of Congress
Cataloging-in-Publication Data

Sander, August.
 August Sander : photographs from the J. Paul
Getty Museum.
 p. cm. — (In focus)
 ISBN 0-89236-567-6
 1. Portrait photography. 2. Sander, August.
3. J. Paul Getty Museum—Photograph collections.
4. Photograph collections—California—Los Angeles.
I. J. Paul Getty Museum. II. Title. III. Series: In
focus (J. Paul Getty Museum)
TR680.S226 2000
770'.92—ddc21 99-28926
 CIP

Contents

Deborah Gribbon **Foreword** **4**

Claudia Bohn-Spector **Introduction** **5**

 Plates **11**

Hilla Becher **Portrait of a People:** **101**
Claudia Bohn-Spector **The Photographs**
Gabriele Conrath-Scholl **of August Sander**
David Featherstone
Sander Gilman
Ulrich Keller
Weston Naef
Joan Weinstein

 Chronology **140**

Foreword

This In Focus book is devoted to the German photographer August Sander, who spent more than four decades taking pictures of his compatriots, creating a collective portrait of the German people. His work has appropriately been described as a monumental physiognomy of his time and as one of the most truly abstract oeuvres in the history of photography. Sander's images, among the finest in the Getty Museum's collection, continue to hold our historical interest and to inspire our creative imagination.

With a total of 1,235 prints, the Museum's assemblage of Sander photographs is second in size only to the August Sander Archiv, Kulturstiftung Stadtsparkasse, Cologne, which houses Sander's estate. The pictures came to the Museum from a variety of sources, including the collections of Samuel Wagstaff, Jr., Volker Kahmen/Georg Heusch, and Erwin Wörtelkamp. In addition, numerous important examples have been added to the holdings individually and in small groups.

On September 4, 1998, the Department of Photographs hosted a colloquium to discuss the work of Sander. I gratefully acknowledge the following participants: Hilla Becher, Claudia Bohn-Spector, Gabriele Conrath-Scholl, David Featherstone, Sander Gilman, Ulrich Keller, Weston Naef, and Joan Weinstein. Their generosity in sharing their collective wisdom is greatly appreciated. I particularly wish to thank Dr. Bohn-Spector for coordinating the project and authoring the plate texts. On her behalf, gratitude is extended to Sabine Hake for her invaluable insights shared during a lecture on Sander at the University of California, Los Angeles, and to Howard Spector.

There are many others, in addition to those listed on the last page of this book, who assisted in the production of this volume, including Mikka Gee, Michael Hargraves, Marc Harnly, Anne Lyden, Ted Panken, and Katherine Ware. It is to them and to Weston Naef, who devised the In Focus series and who continues as its general editor, that I offer these final words of thanks.

Deborah Gribbon,
Deputy Director and Chief Curator

Introduction

The long lifetime of the German photographer August Sander (1876–1964) spanned one of the most turbulent eras in his country's history. Born during the formative years of the Wilhelmine *Kaiserreich*, Sander witnessed Germany's radical transition from a predominantly agrarian society to a modern nation-state. When he was born, the Industrial Revolution had just begun to sweep the land, bringing with it the promises and uncertainties of a new technological age. At the time of his death, Germany was a divided country struggling to master the demons of its past. The Great War of 1914, the Weimar Republic, the reign of National Socialism, and the horrors of World War II all left an indelible imprint on both the man and his work.

In many ways, Sander exemplifies the complex and sometimes contradictory nature of his time. As an artist, he came of age during the Weimar Republic, a tumultuous experiment in democracy bridging Germany's imperial past and the Third Reich. Founded in the bitter aftermath of a lost war, Weimar extended over a period of great social, political, and cultural ferment. Many artists felt called upon to help establish a new order, creating revolutionary art forms, such as Dada, Epic Theater, and *Neue Sachlichkeit* (New Objectivity). A laboratory for modernity, the republic was equal parts utopian dream and civic nightmare, a society torn between progressive visions of the future and reactionary longings for the past. Uneasy political alliances and odd blends of divergent cultural ideologies marked the intellec-

tual landscape of the day, giving rise to hybrid forms of artistic expression that defy easy classification.

Sander's work is no exception. It reflects an artist who was at once innovative and deeply wedded to the past. A conventional studio portraitist who transformed himself into an artist with avant-garde ambitions, Sander blended a progressive aesthetic approach with a conservative view of society and his craft. He was not a friend of experimentation and embraced modernity only reluctantly. Unlike other photographers of this period, who idolized the speed and sophistication of the new technological culture, Sander revered the beauty and stillness of the traditional arts and crafts. At a time when hand-held cameras and fast roll film revolutionized the art of picture making, he used antiquated equipment: a large view camera on a tripod with glass-plate negatives requiring an exposure of several seconds. While other artists explored photography's untapped potential, Sander stuck with the tried and true, preferring the universal and constant to the transient and new. Yet, despite his conservative views, Sander was able to create an innovative body of photographs that continues to hold our interest even today.

Sander was born and raised in the country, where hard work and a love of the land were formative elements of his upbringing. Drawn to photography as a youth, he trained to become a commercial portraitist, eventually running his own business in Linz, Austria. He taught himself the vocabulary of Pictorialism and practiced a painterly, "impressionist" style that suited the traditional tastes of his bourgeois clientele. By the time he closed his Linz studio in 1909, Sander was a recognized photographer whose work frequently received prizes at international competitions. The following year he opened a portrait establishment in Cologne-Lindenthal and began to travel to the adjacent countryside in search of clients. It was here in his native Westerwald that Sander's creative vision fully evolved. Knowing the land and the people well, he soon realized that his rural customers had little use for the middle-class decorum and artistry of standard studio portraiture. Instead, they demanded pictures that reflected their plain, earthbound way of life. Sander began to rethink his approach to photography and responded by creating the sober, straightforward style that became the hallmark of his work.

Sander's artistic conversion was fueled by a group of young painters of the radical Left, the Cologne Progressives, whom he met in the early 1920s. Their

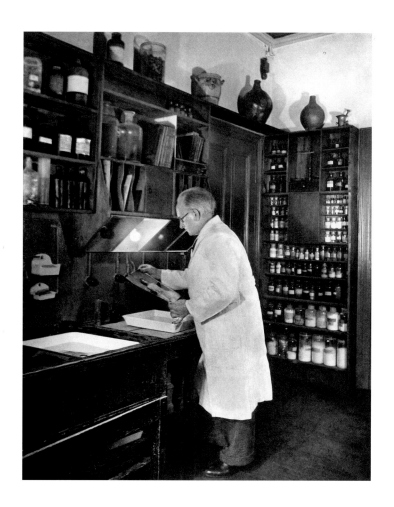

August Sander.
Self-Portrait in His Darkroom, Cologne, 1940.
Gelatin silver print from a circa 1938 negative. 21.6 × 16.3 cm.
Collection of August Sander Archiv,
Kulturstiftung Stadtsparkasse, Cologne.

conversations and debates afforded him a keener sense of the current social and political situation in Germany and inspired some of the intellectual ideas that informed his photography. The painters practiced an art that reduced the human figure to abstract mannequins, or "types," whose pictorial arrangement was meant to reflect the organization of society as a whole. They believed that artworks thus conceived represented steps toward the restructuring of society and even the world. Much less radical in his political views, Sander nevertheless took to these ideas. It was around this time that he first envisioned his "Citizens of the Twentieth Century" ("Menschen des 20. Jahrhunderts"), a series of over five hundred photographs intended as a physiognomic definition of the German people of the period. It was his goal to create a collective portrait of German society during the Weimar era, a truthful outline of the existing social order. With the systematic methodology of a social scientist, Sander assembled in front of his lens individuals from all walks of life—peasants, clergymen, painters, bureaucrats, gypsies, secretaries, bricklayers, nuns, clerks, the unemployed, and the mentally ill—representing them in their daily environments or against neutral studio backdrops. He divided the portraits into seven sections comprising a total of forty-five portfolios, ordering them sequentially to make the existing social order visible. Each section addressed a specific population group: farmers, workers, women, professionals, artists, and city dwellers. His enormous archive ended with "The Last People," those on the fringes of society: the handicapped, sick, and dying.

In 1929, as a preview to his grand enterprise, Sander published *Face of the Time* (*Antlitz der Zeit*), a book of sixty portraits that has since become a classic in the literature of photography. He arranged the pictures in roughly chronological order, tracing Germany's dramatic transformation into a modern industrialized nation. Fraught with many historical omissions and blind spots, which betrayed Sander's conservative views, *Face of the Time* nevertheless embodied facets of social reality that were both fascinating and deeply troubling to contemporary audiences. Not surprisingly, the book's critical reception ranged from lavish praise to wholesale condemnation, underscoring its relevance for a society undergoing far-reaching changes. In 1929 a Rightist critic dismissed the book as a work of "anarchy" and "inferior instincts," anticipating the charges that would later be leveled against the photographer by the National Socialists. In 1936 *Face of the Time*

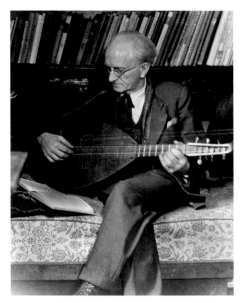

August Sander. *Self-Portrait Playing the Lute,* circa 1940–44.
Gelatin silver print, 22.6 × 16.9 cm. 84.XM.126.68.

was confiscated by Nazi authorities and its halftone plates destroyed. The complex and often contradictory picture Sander had drawn of the German people was ill suited for, if not dangerous to, the propagandistic goals of Nazi ideologues, for it ultimately proved that the typical German did not exist.

With the advent of the Third Reich and the arrest of his son Erich, a member of the Communist Party, Sander's career took a dramatic turn for the worse. The scorn of Nazi authorities, which Sander often provoked by blatantly frequenting Jewish shops and engaging party officials in shouting matches, put an end to his professional ambitions. On the eve of World War II, he moved to Kuchhausen, a small village in the Westerwald, taking with him ten thousand of his most prized negatives. (The remaining thirty thousand glass plates, stored in his Cologne basement during the war, were lost to a fire in 1946.) In Kuchhausen, Sander lived and worked under severe constraints. Like many other contemporary artists, he was unable to continue his politically sensitive work, instead focusing

his attention on landscape photography, a passion he had first developed in the early 1920s. He spent the rest of his life viewing and rearranging the remnants of his archives, trying to finish "Citizens of the Twentieth Century."

In the early 1950s Sander was able to revive old professional contacts in Cologne, due in part to the efforts of his son and assistant Gunther. Sander exhibited at the first Cologne Photokina in 1951 and was selected to participate in the seminal photography exhibition *The Family of Man,* organized by Edward Steichen in 1955 at the Museum of Modern Art in New York. Sander's reputation as one of Germany's formidable photographers slowly grew. In 1960–61 the German Photographic Society honored him with the Cross of Merit and Cultural Prize, and the following year *Mirror of the Germans (Deutschenspiegel),* a selection of his pictures with an introduction by the art historian Heinrich Lützeler, was published. "Citizens of the Twentieth Century," however, remained a fragment. Sander left but few notes to guide historians in their reconstruction of his original intentions. In 1981 Ulrich Keller and Gunther Sander attempted a posthumous publication of the forty-five portfolios, presenting for the first time the full scope of the photographer's extraordinary life work.

Thirty-five years after his death, Sander's ontological project continues to fascinate and intrigue contemporary viewers. Although burdened with many uncertainties and riddled with contradictions, it is a work of exceptional talent, unparalleled to this very day. Blending as it does a fluid, contextual definition of the individual with a static, hierarchical conception of society, "Citizens of the Twentieth Century" is at once progressive and profoundly reactionary. It maintains but a fragile and tenuous balance between the two opposing views, failing to provide the ideological certainties to which Sander aspired. Looking back at the artist's photographs, today's viewer cannot help but marvel at the faith and optimism with which he articulated his essentialist vision. At a time when notions of individuality and subjectivity continue to be challenged by new, virtual technologies, Sander's images testify to the potential, as well as to the limits, of pictorial representation. His ultimate inability to complete his project and to fix its meaning makes his effort all the more compelling.

Claudia Bohn-Spector

Plates

A Note to the Reader

These plates, made between
1912 and about 1942, have
been organized in roughly
chronological order,
moving thematically from
portraits of the Westerwald
farmer to the modern
city dweller and beyond.

PLATE I

Peasant Woman
of the Westerwald
1912

Gelatin silver print
22.9 × 17.5 cm
84.XM.126.169

It is fitting to begin this selection of plates with *Peasant Woman of the Westerwald,* for August Sander had planned to preface his life's work, the proposed "Citizens of the Twentieth Century," with a "portfolio of archetypes" devoted to the peasant as the prototypical building block of human society. "The models for the scheme," he recalled in 1954 in the introduction to the portfolio, "arose from the small area around my birthplace in the Westerwald. People whose habits I had known from my youth seemed, by virtue of their strong connection with nature, ideally suited to the realization of my idea. . . . I classified all the types I encountered in relation to one basic type, who had all the characteristics of mankind in general."

After opening his portrait studio in Cologne-Lindenthal in 1910, Sander often traveled to the small villages and farming communities of the Westerwald in search of new clients. This picture of a farmer's widow from the village of Ottershagen may have been commissioned by her family. The subject is seen seated in an armchair against a dark backdrop holding a book, possibly a Bible. She doesn't reciprocate the viewer's gaze, instead focusing inward as if in solemn contemplation. Sander registers her black garments with archaeological precision; her aged face is framed by the monumental folds of the shawl. In the twelve photographs of peasant men, women, and families that formed the portfolio of archetypes, she appears as "The Earthbound Woman," represented not in her historical dimension, but in her metaphorical role as the mother of German civilization.

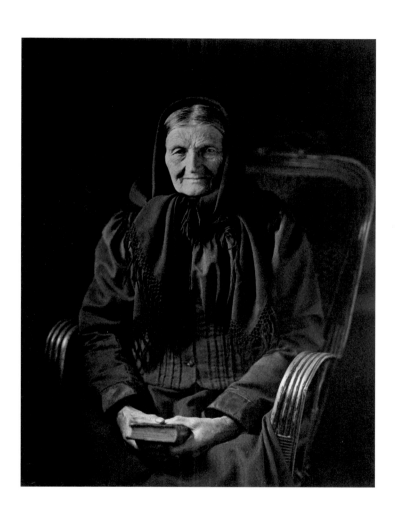

PLATE 2

Shepherd
1913

Gelatin silver print
22.9 × 16.8 cm
84.XM.126.282

Sander observed in a radio lecture delivered in 1931 that "every person's story is written plainly on his face, though not everyone can read it. These are the runes of a new, but also ancient language." He intended "Citizens of the Twentieth Century" to be a physiognomic portrait of the German people, a comprehensive cultural history and social analysis in pictures. In the portfolio of archetypes he established an inventory of core features—a physiognomic "baseline"—against which all other social classes and professions would be measured.

In 1913 Sander photographed the shepherd Hermann Pithahn from the small Westerwald village of Giessenhausen. In the portfolio of archetypes he is referred to as "The Sage." In keeping with the traditions of rural iconography, Sander focused on the peasant's rugged face and plain appearance to convey a sense of natural strength and wisdom. The artist's emphasis on older country folk reflects his desire to capture in their faces the last vestiges of a world that was on the brink of extinction. The shepherd is seen as the last representative of a dying breed.

PLATE 3

Peasant Family

1912

Gelatin silver print
15.2 × 21.6 cm
84.XM.126.283

Sander's treatment of the German farmer represents a unique homage to a vanishing era. It reflects, in part, the country's dramatic transition from a mostly agricultural society to an urban, industrialized state. Toward the end of the nineteenth century, 40 percent of the German population still worked in the countryside; by the mid-1920s, this number was cut almost in half.

When Sander began to photograph in the Westerwald, he soon realized that his rural clients shared few of the aesthetic ideals that were dear to his middle-class customers in Cologne. The peasants demanded portraits that reflected their plain, earthbound way of life. He responded by eliminating from his art all traces of external manipulation and artifice in favor of formal simplicity and sharp pictorial definition. Sander advertised about 1910 that his goal was to create "simple, natural portraits that show the subjects in an environment corresponding to their own individuality."

The family shown here posed for Sander outdoors, at the edge of a pine forest near their home. The parents and two children—dressed in their Sunday outfits—are possibly on their way to or from church. They face the photographer with earnest solemnity, their impeccable dress, formal posture, and stern gazes betraying a strong sense of tradition and moral integrity. Sander photographed at least two other families in the same setting, perhaps suggesting a kinship between the trees in the background and the upright spirit of the peasants in the foreground. He included one of these pictures in the portfolio of archetypes, adding a generational dimension to his anthropological project. By presenting new generations next to older ones, Sander showed how the past gives way to the future in never-ending cycles of renewal and regeneration.

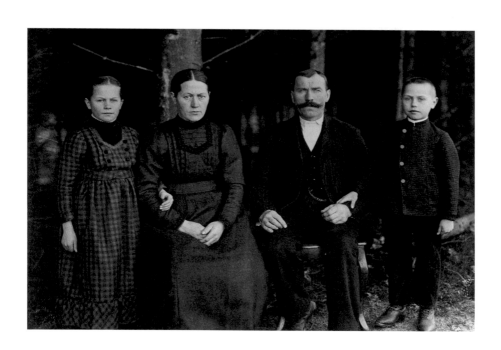

PLATE 4

Dwarfs

1912

Gelatin silver print
16.8 × 17.7 cm
84.XM.126.83

Sander planned to arrange the portraits in "Citizens of the Twentieth Century" according to a circular system. Beginning with the earthbound farmer, the photographs would ascend through all the social classes and professions to "the representatives of the highest civilization" before descending to the "idiots, the sick . . . and the dying," he noted in the work. This arrangement reflected his belief that civilizations develop in cyclical patterns, an idea popularized by the historian Oswald Spengler (1880–1936) in his two-volume *Decline of the West* (1918–22). According to Spengler, all great cultures are rooted in the country, gradually evolving from primitive barter societies to sophisticated urban markets before collapsing in the complex and soulless bureaucracies of the metropolis. An avid reader of Spengler, Sander subscribed to the idea that social groups follow each other in chronological succession: those appearing early in a society's life cycle—the peasant and his family—were regarded qualitatively as the highest, while those supposedly appearing last—beggars, vagrants, and the mentally ill—were considered the lowest.

Sander entitled the final section of his photographic inventory "The Last People." It included this portrait of two young men from Nistertal, southeast of Cologne. One of the subjects is identified on the glass-plate negative as Mr. Hamrich, suggesting that the portrait was commissioned by him. The photograph serves a double function. As a commercial portrait, it is an official record of the pair at a particular moment in time, documented without critical intent. However, in Sander's typology, conceived many years after the picture was made, the image becomes part of a larger story. Here the men's physical condition immediately marks them as outcasts, representatives of a "late" stage of social evolution.

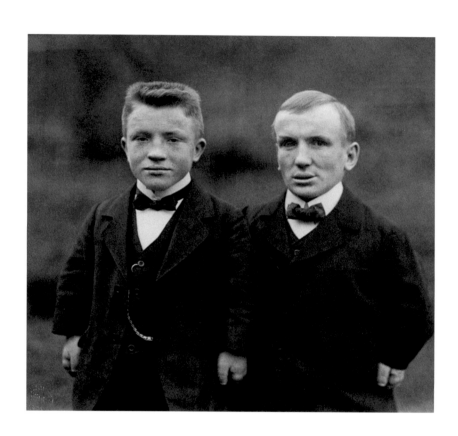

PLATE 5

Young Farmers

1914

Gelatin silver print
23.5 × 17 cm
84.XM.126.294

Having grown up in the Westerwald and speaking the local dialect, Sander knew the land and its people well. In this picture he focuses his lens on three young farmers he probably encountered on one of his frequent Sunday cycling trips to the area. The men are caught in transit, their walk interrupted when they happen upon the itinerant photographer. Their identical dark suits, snappy hats, and walking sticks suggest that the desire of young people to dress alike is not new. The men are en route to a dance in a neighboring village, rural flaneurs on their way to meet the girls. As if arrested in mid-stride, they turn their heads to face the camera. Time and motion in this image seem strangely suspended, lending the scene an eerie, cinematographic quality that is quite different from the static portraits Sander had produced earlier. The picture overflows with descriptive information and narrative detail, yet it remains ambiguous and open to interpretation. What was the men's relationship to each other and to the photographer? What was the nature of their transaction?

It is unclear whether this is a commissioned portrait or whether Sander took the picture on his own initiative, discovering in the subject a deeper philosophical significance and artistic challenge. He may have sensed that the journey of the three men was also an allegorical one: from youth to adulthood, from country to city, from the familiar geography of the past to the disjointed spaces of modernity—a whole generation of young, rural males caught in limbo. The realization that these are the men who would soon fight and die in the Great War imbues the scene with a sense of melancholy—a mournful foreshadowing that probably was not lost on Sander.

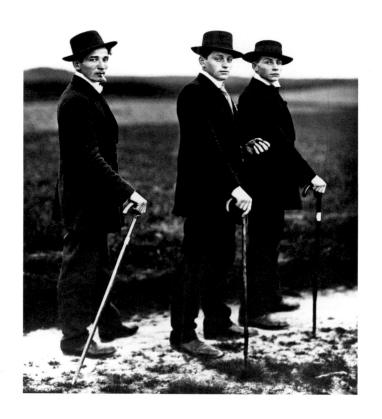

PLATE 6

**Rural Wedding
Portrait**

1913

Gelatin silver print
23.5 × 16.5 cm
84.XM.126.165

This photograph of a young rural couple on their wedding day is as rich in narrative detail as *Young Farmers* (pl. 5) yet less laden with symbolic meaning. The young man, identified on the glass-plate negative as Peter Schmidt, is seen with his wife in front of a wooden barn, their formal attire and stiff poses appropriate to the seriousness of the occasion. The photographer describes without emphasis or passion the bride's high-necked black gown, the satin rosette pinned to her chest, and her pearly diadem and brooch. She is the epitome of a traditional peasant bride. The small branch in her hand is a decorative prop frequently used by Sander to lend his female sitters an air of natural repose and ease, a device that seemingly fails in this instance.

The bride's chaste appearance and directness is strangely at odds with her husband's portentous demeanor. His slick, fashionable grooming and calculated pose betray a theatrical consciousness that is absent in his wife. The oversized coat, stylish necktie, and bowler suggest a latent desire to project an aura of urban sophistication and elegance. The man's work-roughened hands and the humble setting, however, give him away.

Sander rarely interfered with his clients' performances in front of the camera, thereby acknowledging the importance of role-playing in portrait photography. This image reveals how his subjects saw themselves, how they wanted to be seen by others, and how they wished this event to be preserved for posterity.

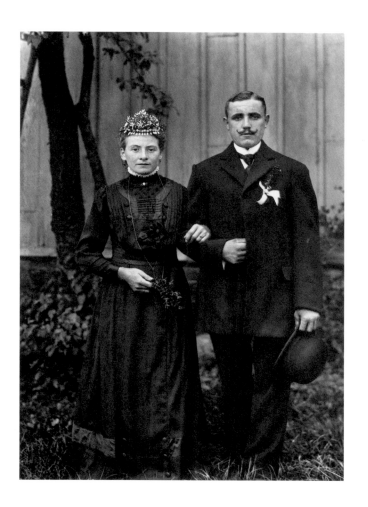

PLATE 7

Group of Children, Westerwald

1913

Gelatin silver print
27.5 × 22.6 cm
84.XM.126.4

In 1913 Sander photographed the three children of the Gehlhausen family, owners of a guest house in Weissenbrüchen. The youngsters are depicted in the company of their dog and toys, facing the camera with deep, unbridled suspicion. A recent downpour has turned the dirt road on which they are standing into mud, making the outdoor session a particularly unappealing endeavor. The boys are dressed for the occasion in crisp, pin-striped navy costumes. Their baby sister, propped up in her wooden carriage, is fretfully hanging on to a doll. The boy on the right holds his whip like an alien implement, making no attempt to use it on the hobbyhorse in front of him.

Sander tightly framed the scene, lowering his camera and moving in closely on his subjects. Had he opened his lens a little further, it might have revealed an array of cajoling adults standing close by, pleading with the children to hold still and not spoil their spotless clothing. Only the dog, who guards the miserable trio with an impish smile, seems to be enjoying the experience.

Sander approached the scene before him like a true documentarian, humorously registering the youngsters' lackluster performance in front of his lens. It has been observed that the image is reminiscent of the popular painting *The Hülsenbeck Children* (1805) by the Romantic artist Philipp Otto Runge (1777–1810), in which the three subjects are represented at lively play in their garden. This photograph, however, is Runge's painting gone terribly wrong. Libertine playfulness gives way to a frightening display of Wilhelmine discipline—a subtle parody on Sander's part that was sure to amuse the sophisticated urban audience at which his larger project was directed.

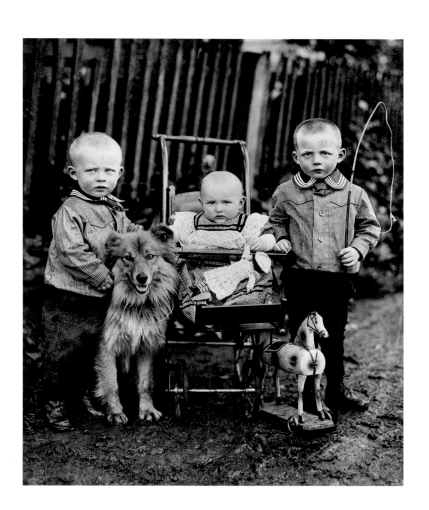

PLATE 8

Child, Westerwald

Circa 1911–14

Gelatin silver print
10.6 × 6.9 cm
85.XM.258.266

Sometime between 1911 and 1914 Sander took this photograph of a little boy around two years of age. He is seen standing on a chair, holding his hands up in the air for balance. The child's plump figure and rosy cheeks suggest that he has been getting plenty of food and fresh air. His eyes are fixed on someone standing next to the photographer, possibly an eager family member trying to hold his attention while Sander operates the camera. Another figure, maybe the boy's mother, is barely discernible in the background, guarding against an unexpected fall. The final print has been retouched in an attempt to remove her, maintaining the picture's near-perfect composition.

Blending keen observation with technical mastery, Sander has captured an image that is remarkably sweet and endearing. The child's pin-striped outfit and black leather boots are magnificently rendered against the dark interior, the whiteness of his youthful skin skimming the print surface like a precious highlight. Sander's sensitivity to his subject and ability to grasp every nuance of the boy's expression reveal him to be a master photographer as well as a great lover of children.

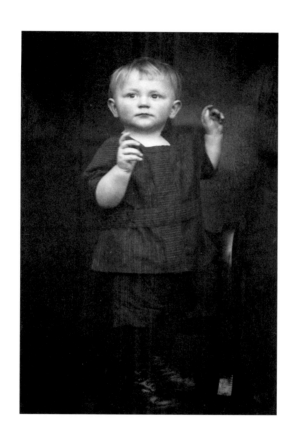

PLATE 9

Child, Westerwald

Circa 1926–27

Gelatin silver print
40.9 × 37.1 cm
85.XM.258.435

Sander enjoyed the company of children and was known around his Cologne neighborhood for his ability to tell a good story and nurture sick pets back to health. He is said to have shown up for his portrait assignments with toys and hand puppets in his pocket, ready to provide entertainment for reticent youngsters.

Sander's technical equipment remained decidedly old-fashioned throughout his career. For his portrait work he relied largely on an antiquated Vogtländer lens, a view camera on a tripod, and large glass-plate negatives. The fact that this gear required an exposure time of up to four seconds is doubly important when considering this image of a little peasant boy balanced precariously on a bike, accompanied by the family's hunting dog. How the photographer managed to keep the toddler in position and hold the attention of both the child and the dog for the time it took to make the exposure is a question that will have to remain unanswered. The fact that Sander printed the picture in an unusually large format and signed it for exhibition is evidence that he considered it a masterpiece, a Herculean accomplishment indeed.

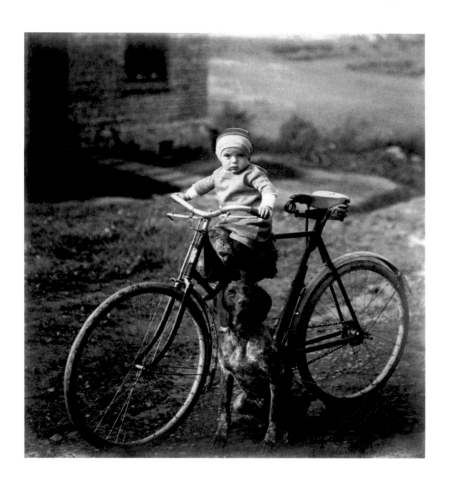

PLATE 10

**Hähner Family,
Ückertseifen,
Westerwald**

Circa 1910–14

Gelatin silver print
10.8 × 15.1 cm
85.XM.258.370

PLATE 11

**Mr. and Mrs. Hähner,
Ückertseifen,
Westerwald**

1926

Gelatin silver print
15 × 10.4 cm
85.XM.258.174

PLATE 12

**Mr. and Mrs. Schenk,
Ückertseifen,
Westerwald**

1926

Gelatin silver print
15 × 10.2 cm
85.XM.258.338

Sander frequently returned to the farming families he had documented earlier to make pictures of a funeral, the wedding of a daughter, or the confirmation of a grandchild. He went about all these assignments with the same diligent professionalism, recognizing that they were the bread and butter of a portrait photographer. He first recorded the Hähner family from Ückertseifen about 1910–14 (pl. 10), depicting the parents and three children in their backyard. It is a routine image, executed without great inspiration or passion. In 1926 Sander was called upon again, this time to create a portrait of the oldest Hähner son and his wife of two years (pl. 11). Sander also photographed the family's neighbors, Mr. and Mrs. Schenk (pl. 12), who wished to have their likenesses taken at the same site as the young couple.

The difference in quality in these three photographs is striking. The two double portraits possess a formal beauty and freshness of vision that are absent from the earlier image. It is interesting to contemplate what inspired Sander to break away from his routine and to make pictures of such visual impact and consequence. The impulses that activate an artist's creativity often arise in mysterious and serendipitous ways. Maybe it was the beautiful diffused light that day that caught Sander's attention. Maybe it was the realization, heightened by his experience of World War I, that the people in front of his lens possessed a rare dignity and grace that was worthy of commemoration. Whatever it was, the portraits Sander created of the couples are stunning.

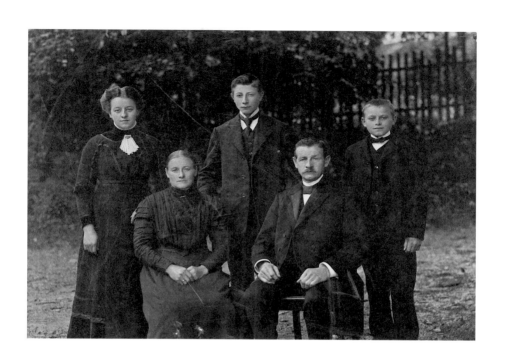

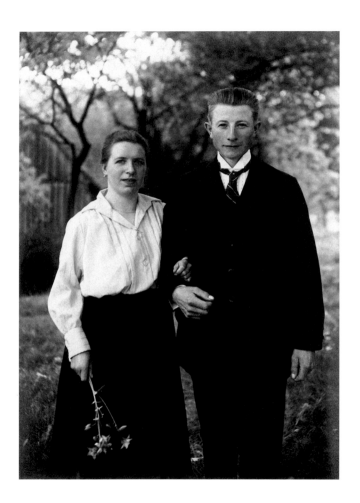

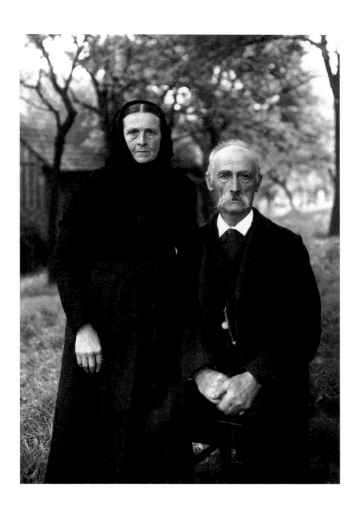

PLATE 13

Farm Girls
1928

Gelatin silver print
22 × 15.9 cm
84.XM.126.534

Sander considered a successful photograph only a preliminary step toward the intelligent use of his art. "Photography," he wrote in a letter to the Cologne painter Peter Abelen in 1951, "is like a mosaic that becomes a synthesis only when it is presented *en masse*." He intended his portraits to be seen as a series, each image building and commenting on the other. It is not from the individual pictures that the meaning of Sander's typological project flows, but from the carefully orchestrated relationships among them.

In 1929 Sander published *Face of the Time,* a book of sixty photographs intended as a preview of his larger effort. He included this image of two farm girls, taken in 1928. The teenagers, identified on the negative as sisters, are shown on a narrow country road in front of a diffuse backdrop of foliage. The uniformity of their outfits—the identical black dresses, wristwatches, and decorative rosettes—is matched by their listless, almost sagging poses. The absent-minded stare of the girl on the left and the drooping flower in her hand set the emotional tone of the picture. An intense psychological ambiguity hovers darkly about the scene, as if the flow of time had suddenly thickened and caught the girls in a trance—sleepwalkers in an uncanny twilight zone.

While it is not known how Sander came to take this picture or whether he saw in it a deeper philosophical message, it is noteworthy that he positioned the image in *Face of the Time* immediately following that of the three young farmers en route to a dance (pl. 5), thereby suggesting an intimate connection between the two. Striking different registers of the same emotional chord, both photographs convey a pervasive sense of uncertainty, displacement, and loss—a melancholy comment, perhaps, on the bruising encounter of the peasant with the urban industrial machine.

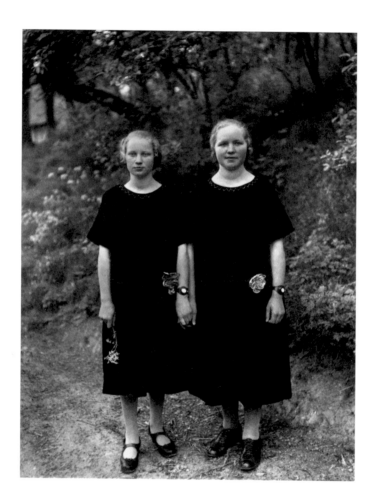

PLATE 14

**Blacksmith,
Westerwald**

Circa 1930 gelatin silver print
from a 1913 negative
28.4 x 21.9 cm
84.XM.126.227

PLATE 15

**Peasant Woman,
Westerwald**

Circa 1930 gelatin silver print
from a 1910–14 negative
17 x 11.7 cm
84.XM.126.364

PLATE 16

**Peasant Woman,
Sauerland**

Circa 1930 gelatin silver print
from a 1910–14 negative
18.9 x 13.9 cm
84.XM.126.355

Throughout the 1930s Sander was busy assembling the material for "Citizens of the Twentieth Century." He began sorting through his archives of old negatives, going as far back as the early teens, reprinting many of his commissioned portraits for incorporation into his system. Among them were these photographs of a blacksmith and two peasant women.

As he worked, Sander extracted tightly cropped head shots from full-length portraits, creating a standardized format to facilitate the contemplation of the different human types on display. In look and function, these images are reminiscent of ethnological photographs executed by the hundreds of thousands in the late nineteenth century. However, instead of documenting the exotic peoples of faraway places, Sander's pictures trace the different physiognomies and "tribes" of his native Germany. As the physician and writer Alfred Döblin (1878–1957) noted in his introduction to *Face of the Time,* the pictures' scientific stance invites comparison: "Just as there is a comparative anatomy which enables one to understand the nature and history of organs, so here the photographer has produced a comparative photography, thereby gaining a scientific standpoint which places him beyond the photographer of detail." Similarly, the writer and critic Walter Benjamin (1892–1940) observed in "A Short History of Photography" (1931): "Sander's work is more than a book of pictures. It is a training manual."

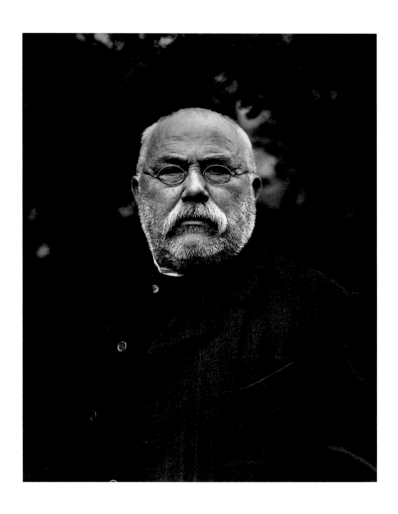

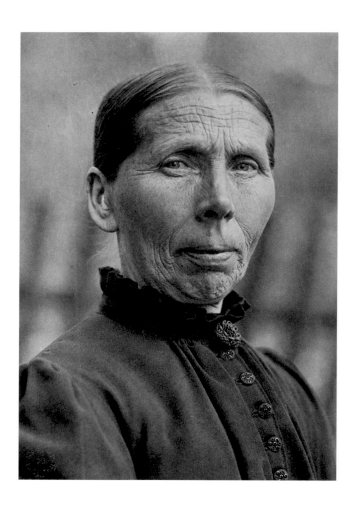

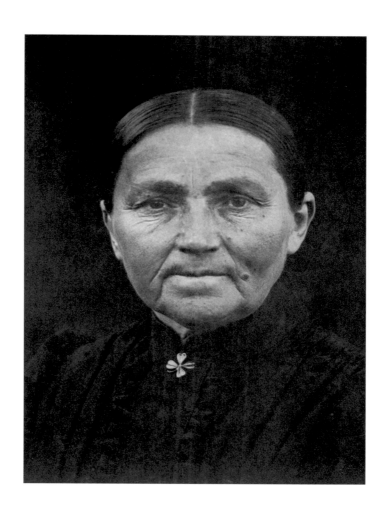

PLATE 17

Study of a Priest
and an Acolyte

1927

Gelatin silver print
28.8 × 22.6 cm
84.XM.498.7

Throughout his life Sander preferred to work at home, in the areas around Cologne and the Rhineland. He seldom ventured into the big cities or the industrial belts of the Ruhr or Saar Rivers, focusing instead on the land and the people he knew best. This photograph was taken in 1927 on one of his rare excursions outside Germany.

In 1926 Sander had been approached by the writer Ludwig Mathar (1882–1958) to collaborate on an illustrated volume on Sardinia. Known for a popular travel guide to Italy and several works of fiction, Mathar was a great admirer of Sander's. The following year the two journeyed south, spending three months on the Mediterranean island researching and taking pictures. Although the book they envisioned never materialized, the pair managed to publish a short article featuring Sander's photographs and a text by Mathar.

Sander made more than five hundred negatives in Sardinia, most of which were picturesque studies of the island's old villages and the traditional ways still practiced by the inhabitants. In this body of work, the mysterious photograph of a priest and an acolyte is an anomaly. The priest is seen blessing or anointing a young man kneeling before him in an earthen pit, the youth's gaze transfixed as if he were beholding a holy apparition. It is not known what the event signifies or how Sander came to witness it, but the image's strange ambiguities and evocativeness are reminiscent of his best work from the Westerwald.

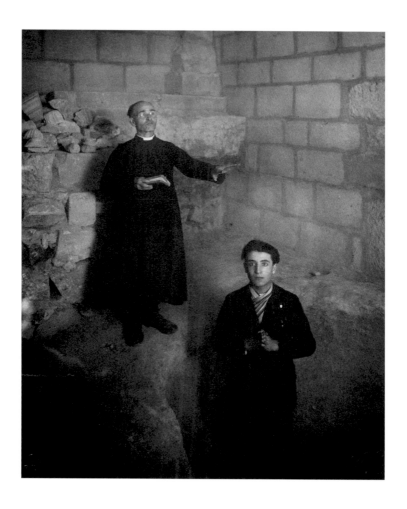

PLATE 18

Socialist Leader
Paul Fröhlich

1929

Gelatin silver print
22.5 × 14.9 cm
84.XM.126.193

Sander arranged the sixty photographs in *Face of the Time* in roughly chronological order, moving from country to small town to big city before concluding with the urban underclass: the derelicts and the unemployed. With the systematic methodology of a social scientist, he assembled typical specimens that defined the nation at the time. He devoted a large portion of his book to the city and to representatives of intellectual labor—the white-collar worker, politician, clerk, agitator, scholar, artist, and critic—thereby pointing to the slow disappearance of the farmer and the preindustrial trades from the center of German society.

It was Sander's intention to present each sitter in an environment that suited his or her social role. Peasants are most often seen outdoors embedded in nature, while workers and craftspeople appear in situations shaped by their labor: a factory, workshop, or studio. The setting defines and interprets the subjects. By contrast, the representatives of the educated middle and upper classes are frequently depicted against neutral backdrops. The socialist leader Paul Fröhlich, for example, poses in front of a flat, light-colored wall. He is portrayed by Sander as a true member of the intellectual elite; no props or demonstrative gestures seem necessary to provide additional information about him. In stark contrast to the proletarians, whose political interests he represents, Fröhlich speaks for himself.

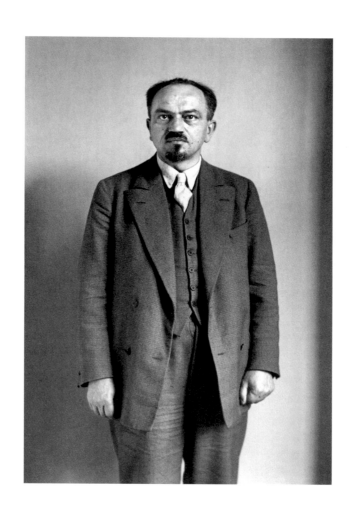

PLATE 19

Savings Bank Cashier, Cologne

1928

Gelatin silver print
26.1 × 20.8 cm
84.XM.126.522

Germany's rapid modernization brought about a dramatic increase in salaried employees: stock clerks, accountants, government bureaucrats, secretaries, bookkeepers, and other administrative officials working in the new service industries of the Weimar era. As a social group, white-collar workers suffered many economic insecurities, vulnerable as they were to the fluctuations of the financial markets and the currency crisis of the early 1920s. As a result, they received considerable political and sociological attention. Siegfried Kracauer (1889–1966), in his famous study *White-Collar Workers* (*Die Angestellten*) of 1929, attested to the "intellectual homelessness" that beset the new employees. "For the moment," he wrote, "they are incapable of finding their way to their comrades, and the house of bourgeois ideas and feelings in which they previously lived has collapsed due to the erosion of its foundations, brought on by economic development. They are living at present [. . .] without a goal to guide them. They live, therefore, in the fear of looking up and dissolving in a welter of questions."

Under the general rubric of "The Professions," Sander planned to devote only one portfolio to "The Official," all but overlooking the growing significance of salaried office labor. The portfolio was to include this portrait of a sober-looking bank clerk. He appears in his barren, nondescript booth in front of a monumental cash machine, holding a paper slip as a sign of his abstract occupation. His monotonous activity is written all over his bland appearance. "In reality," the journalist Margot Starke wrote in a 1923 *Der Querschnitt* indictment of bank clerks, "his head is a calculator, his arms respectively a pencil and a pen stand, his legs two rulers, and his body a ledger in which he writes most maliciously, unconscious of his degeneracy, 'In God We Trust.'"

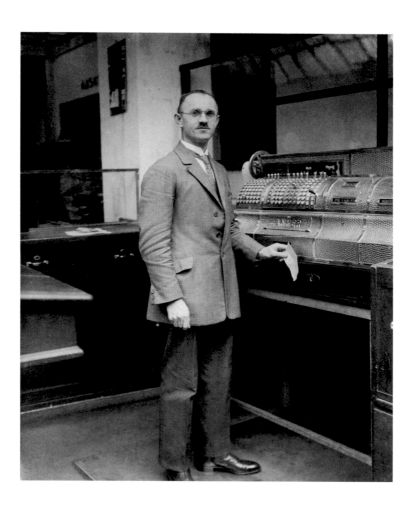

PLATE 20

Young Bourgeois Mother

1926

Gelatin silver print
14.8 × 16.9 cm
84.XM.126.122

Sander first announced his physiognomic project in 1927, when he showed his photographs in an exhibition of modern art at the Cologne Kunstverein. "I am often asked," he wrote in a statement in conjunction with the exhibition, "how I came upon the idea of creating this work: Look, Observe, and Think and the question is answered. Nothing seemed more appropriate to me than to render through photography a picture of our times which is absolutely true to nature."

Here Sander used his considerable talent on a young woman posing with her baby son and pinscher. Her loosely cut linen dress, bobbed hair, and relaxed posture exude an air of refined affluence, suggesting that she is enjoying material comforts and plenty of leisure. In *Face of the Time* she is identified as a member of the German bourgeoisie, a modern housewife and mother.

Sander preferred to depict his female sitters in traditional roles, in sharp contrast to the increasing importance and political power of women in Weimar Germany. By the mid-1920s over eleven million female wage earners reported to work each day, representing one-third of the entire German labor force. Yet Sander devoted only a single portfolio in "Citizens of the Twentieth Century" to them, and in it they appear mostly nameless, in the company of their husbands and children. By reducing the millions of working women to a small minority, Sander skewed the historical record, revealing one of the many blind spots in his analytical project. His photographs, rather than presenting the world "absolutely true to nature," instead offer an interpretation, a window onto the world as it was perceived from a male perspective.

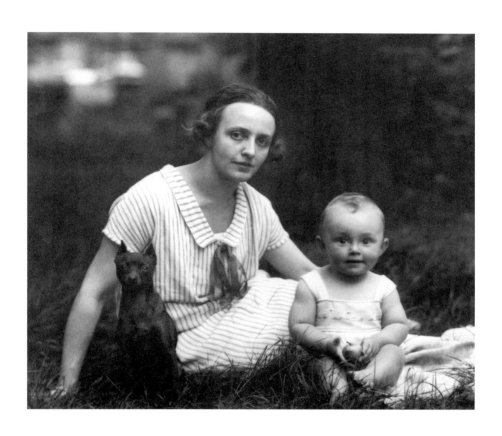

PLATE 21

Wife of the Cologne
Painter Peter Abelen
1926

Gelatin silver print
23 × 16.3 cm
84.XM.498.9

During the 1920s Sander befriended many Cologne artists. In 1926 he was asked by the painter Peter Abelen to create a portrait of Abelen's young wife, Helene, who posed in their apartment surrounded by her husband's artworks. The resulting picture is a striking anomaly in Sander's work, an image so stylishly suggestive and clever that a viewer might expect to find it in the pages of a glossy women's magazine. It may be the closest Sander ever came to taking a sophisticated fashion shot.

The model is seen in masculine garb, wearing a crisp white shirt, a thin necktie, and trendy pants. Sporting a man's hairstyle and clenching a cigarette between her teeth, she signals her defiance of traditional gender roles. In a gesture both daring and tantalizing, she holds a match to the striker, ready to ignite the scene by the sheer force of her determination. She is literally and figuratively playing with fire, testing the limits of her transgressive stance. This is the so-called new woman of Weimar, a glittering media image of the emancipated female that was both fascinating and deeply threatening to the German establishment of the time.

Many years after this photograph was taken, the Abelens' daughter (see p. 122) remarked that the woman in this picture was really Peter's creation. On or off camera, he liked to shape every aspect of Helene's appearance, designing her clothes and cutting her hair. It seems that her provocative posture was also his idea—a self-conscious enactment of the new woman he desired as his wife. The viewer, therefore, is witnessing a carefully orchestrated performance, a theatrical ploy that is at once seductive and unnerving. It is not known how the photographer figured in all this, whether he was an eager participant in or unwitting accomplice to the private fantasy projected by his clients.

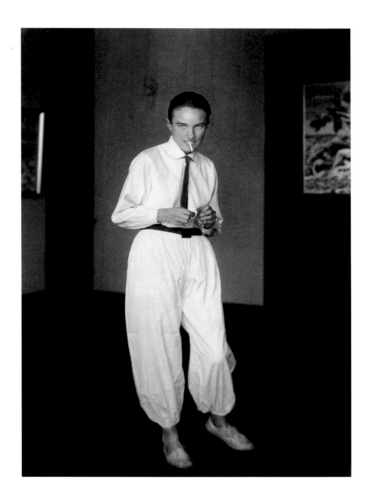

PLATE 22

Bohème

1922

Gelatin silver print
21.8 × 17 cm
84.XM.126.131

Sander's Cologne studio was a popular gathering place for young artists, who engaged the photographer in lively debates about the pressing social and aesthetic concerns of the day. Although he was considerably older than most of them, he frequently showed his work in their exhibitions. In 1922 Sander made this picture of his friend Gottfried Brockmann (1903–83), a young painter who was associated with the Cologne Progressives and who lived with the Sanders for almost two years. The image shows Brockmann in front of a neutral backdrop, his effeminate slouch and solicitous gaze violating all conventional rules of masculinity.

In their stunning reversal of gender roles, the portraits of Brockmann and Helene Abelen (pl. 21) point to an interesting problem in Sander's physiognomic enterprise. By providing vivid proof that social identities in Weimar Germany were far more fluid and complex than even Sander may have realized, they began to undermine his classificatory system. At a time of chaotic struggle between the old and the new, they resisted precisely the certainties that Sander's typological project was supposed to provide, namely that people could be documented, classified, and thus understood. John Szarkowski, in his consideration of Sander's work in *Looking at Photographs* (1973), said that "his pictures show us two truths simultaneously and in delicate tension: the social abstraction of occupation and the individual soul who serves it." Fortunately, Sander was too good a photographer to let the individual in his portraits slip by without notice. Yet, to the degree that the unique and ambiguous asserted itself, Sander's structure came undone. Rather than confirm that the typical German was still accessible to interpretation, it proved that he did not exist.

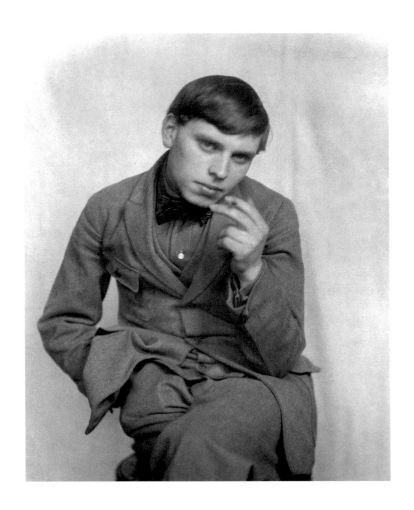

PLATE 23

Parliamentarian of the Democratic Party

1928

Gelatin silver print
22.6 × 15.6 cm
84.XM.126.168

Sander planned to incorporate in "Citizens of the Twentieth Century" a portfolio devoted exclusively to the politician. As Ulrich Keller has pointed out, Sander did not have access to the higher echelons of the German political establishment and had to content himself with the sometimes rather odd players populating the lower ranks. "German politics of the 1920s," Keller wrote in *August Sander: Citizens of the Twentieth Century* (1986), "was a playground for the frustrated and the displaced, who sought in party membership what private life had denied them." Assembled in front of Sander's lens were representatives from the fringes of the political spectrum: the founders of the League of Spiritual Renewal and the Socialist Workers Party as well as functionaries of the German Communist Party. It

was probably Sander's son Erich, a theology student and a Communist himself, who introduced his father to many of them.

In this portrait, made in 1928, Sander presents the businessman and parliamentarian Johannes Scheerer. He is standing against a neutral backdrop, wearing a large black cape, cutaway collar, and wide-brimmed hat. He shoulders his umbrella like a shotgun, measuring up the viewer with an owlish, suspicious glance. Behind this formidable facade seems to lurk a man of many idiosyncrasies, a strange bird more akin to a provincial schoolmaster than a legislator.

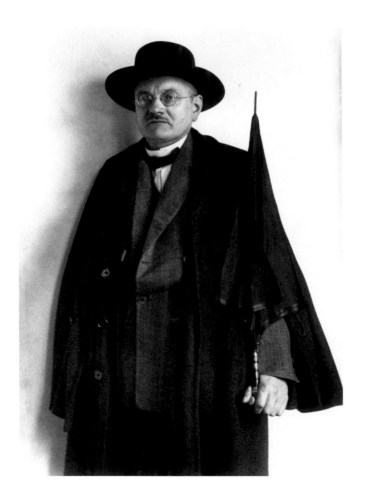

PLATE 24

Cleaning Woman

1927

Gelatin silver print
23 × 15.9 cm
84.XM.126.111

It has often been said that Sander recorded only the typical in the faces and bodies of his subjects. But as Susan Sontag notes in her 1973 book *On Photography*: "It was not so much that Sander chose individuals for their representative character as that he assumed, correctly, that the camera cannot help but reveal faces as social masks. . . . All his subjects are representative, equally representative, of a given social reality— their own."

In 1927 Sander made this portrait of an unidentified cleaning woman. She appears in a cheap dress and an apron covered with old stains, the years of hard, underpaid labor written plainly on her face. The broom handle that she demonstratively holds across her chest is a sign of her lowly occupation. The woman's humanity recedes almost completely behind her socially assigned function. It is only in the small safety pin she has used to close her collar that one begins to sense the full tragedy of her existence—a lifetime of deprivation and joyless struggle, spent in the service of others.

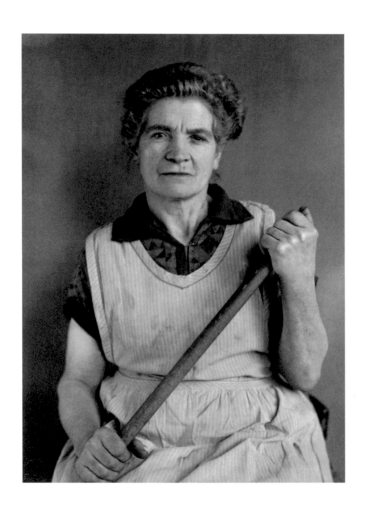

PLATE 25

Beggar Couple, Neuwied

1928

Gelatin silver print
24.3 × 18.2 cm
84.XM.126.181

The Weimar Republic inherited from its imperial forebear a tremendous social burden: over four million disabled veterans, one million orphans, and many more people left homeless and out of work in the aftermath of a lost war. The German economy was in ruins, weakened by the effect of punitive reparations and the rapid devaluation of the German mark. With inflation skyrocketing, a new currency was introduced in 1923, causing the majority of middle- and lower-class Germans to suffer the near total loss of their savings.

The human costs of the war and the ensuing economic crises were high. Many observers noted the intense personal dramas played out every day in the streets of the big cities. The downtrodden, the crippled, and the maimed attracted the attention of many avant-garde artists, inspiring them to create timeless depictions of these individuals and their plight. Painters such as Otto Dix (1891–1969) and George Grosz (1893–1959) were primarily interested in the urban outcast as the heroic victim of political circumstance. Sander, by contrast, was concerned with the everyday flotsam of metropolitan life—the gypsy, mendicant, vagrant, and drifter. In this photograph he focuses on a beggar couple from Neuwied, depicting them in the street, their habitual terrain. The sure gaze of the documentarian misses nothing: the man's clenched teeth, the woman's questioning brow, and the self-conscious gesture with which she reaches for the button of her coat. By observing impassively, Sander penetrates the surface, uncovering the deep sense of bitterness and shame these subjects feel about their station in life.

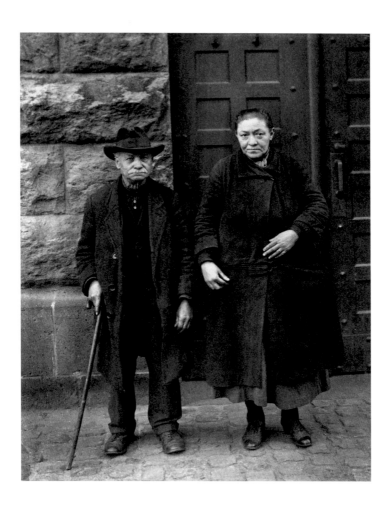

PLATE 26

Unemployed

1928

Gelatin silver print
22.8 × 9.2 cm
84.XM.126.54

The Wall Street crash in October 1929 had a particularly disastrous effect on the German economy. It caused a withdrawal of American loans and thus a credit crisis of unprecedented proportions. By 1932 the number of unemployed exceeded six million. "An almost unbroken chain of homeless men extends the whole length of the great Hamburg-Berlin highway," noted the German travel writer Heinrich Hauser in his 1933 essay "The Unemployed." "There are so many of them . . . that they could shout a message from Hamburg to Berlin by word of mouth." The unexpected death of Gustav Stresemann, the German foreign minister and former chancellor, just weeks before the crash became for many the ominous symbol of a calamitous year, the first cracks in the not-too-solid foundation of the Weimar Republic.

In an interesting confluence of events, 1929 also saw the publication of Sander's *Face of the Time.* It was released by Kurt Wolff's Transmare Verlag in Munich, which had acquired a reputation for publishing the work of Franz Kafka, the Expressionist poets, and *Neue Sachlichkeit* photographers such as Albert Renger-Patzsch. Sander's book traced precisely the sociopolitical development that now so painfully revealed itself as a Faustian bargain: Germany's transformation from an agrarian society into an unstable center of international capitalism.

Anticipating Germany's economic decline, Sander poignantly ended his book with a picture of an unemployed man loitering at a street corner. The photograph shown here is an important variant of that image. The man has lost all attributes of honor and social respectability: his head is shaved, his shirt and suit are torn. He represents the depersonalized existences that, according to Oswald Spengler, populate the urban wasteland in its final degenerate stage. On the glass-plate negative the subject is identified as "The Last Man"—a striking counterpoint to the solidly rooted "eternal man" who had opened Sander's sequence.

PLATE 27

Courtyard Musicians, Cologne

1928

Gelatin silver print
29.3 × 20.2 cm
84.XM.126.88

Sander planned to include in "Citizens of the Twentieth Century" a large section devoted to the modern city, containing ten portfolios with mixed thematic materials ranging from the street, the circus, itinerants, festivities, and city youth to servants, urban types, the persecuted, and political prisoners. The section was to include this photograph of two musicians, which Sander had made in 1928.

At first sight, this is an image full of anecdote and local color, calling to mind the pictures of the popular Berlin photographer and graphic artist Heinrich Zille (1858–1929). An accordionist and a fiddler perform in what appears to be the interior courtyard of a big apartment building. A young woman is leaning out of a second-floor window, listening. In stark contrast to Zille's work, however, this portrait seems very carefully arranged, exhibiting the same staged formality of the image of the Gehlhausen children (pl. 7). The accordionist, for instance, his instrument resting solidly on his velvet-covered lap, makes no attempt to play a tune.

A determined opponent of the snapshot, Sander had little appreciation for the accidental dimensions of a scene. He incorporated narrative elements only to the extent that they prevented monotony. His photographs condense and concentrate time, highlighting the timeless over the temporal, the universal over the contingent. Luckily, he stayed clear of the maudlin, picturesque depiction of "metropolitan types" that had been a key ingredient of urban iconography since the early nineteenth century. He wanted to engage viewers' critical faculties, rather than indulge their sentimental yearnings, thus opening the scene before his lens to deeper analysis.

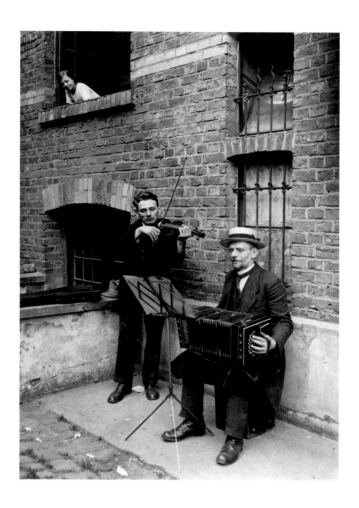

PLATE 28

Police Officer

1926

Gelatin silver print
23.9 × 14.9 cm
84.XM.126.195

For Sander, making a portrait entailed an intimate dialogue between the sitter and himself. He actively encouraged his models to express themselves through dress and gesture. Unlike other commercial studio photographers, he strove to maintain a high degree of critical distance throughout the process, allowing his clients' self-projections to unfold without much comment or interference.

In 1926 Sander photographed this policeman, who posed in front of a neutral studio backdrop, holding a saber as the insignia of his official authority. His mustache, teased into a handlebar of monumental proportions and worn with considerable panache, attests to the officer's sense of style and self-importance. One may suspect that his flashy grooming is meant to compensate for the lack of rank so painfully evident in his plain, undersized uniform.

The writer Max Kozloff observed in a 1973 *Artforum* article that one of the wonders of Sander's photography is his "unconscious ability to evoke caricature without anyone so much as grimacing, cracking a smile, or rolling an eye. Somewhere, deep in his work, there is a comic affinity with [Buster] Keaton, an imperturbable, chaste ridiculousness, which might almost have disarmed us were we not so aware that the society of which people were such vivid fixtures came to a bad end."

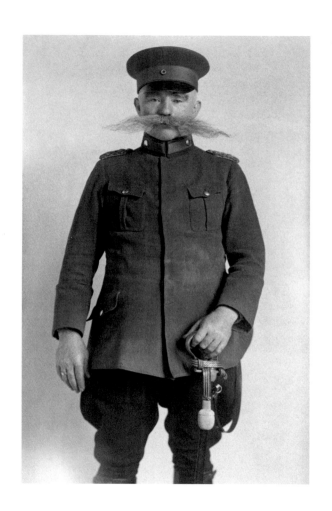

PLATE 29

Coal Carrier, Berlin

1929

Gelatin silver print
24 × 15.3 cm
84.XM.126.52

In addition to the assumption that civilizations evolve in cyclical patterns, Sander believed that society was organized according to a hierarchy of occupations. He planned to arrange his photographs according to an "estate" or "guild" system. Guilds, in medieval times, were associations of persons of the same trade formed for mutual protection and the maintenance of professional standards. They were fraternities of merchants and artisans and had distinct social and political functions.

As Ulrich Keller has observed, Sander's guild system frequently clashed with the actual division of wealth and power in Weimar society. In *August Sander: Citizens of the Twentieth Century* Keller points in particular to the guild system's incompatibility with Spengler's philosophy of decadence. If indeed twentieth-century society consisted of a healthy, solid guild structure,

as Sander proposed, how could this assumption be reconciled with his simultaneous postulate of an unstable, gradually deteriorating society? It was a contradiction that the artist either did not recognize or was unable to solve. Whatever its theoretical shortcomings, Sander's guild system served him well in his outline of the preindustrial trades. In the finest gradations he was able to show the traditional craft structure from apprentice to journeyman to master.

In this picture, taken in 1929, the photographer captures a coal carrier from Berlin stepping out of a building. In Sander's system, the worker is immediately identified as belonging to the lower ranks of manual labor. His place, Sander seems to suggest, is deep inside the bowels of German society—like the dark basement from which he emerges.

PLATE 30

Female Bricklayers, Austria

Circa 1930

Gelatin silver print
22.4 × 15.8 cm
84.XM.126.398

Around 1930 Sander made this photograph of a pair of female bricklayers on a street in Austria, thereby pointing to the important role of women laborers in a trade still dominated by men. The two are standing in front of a wooden scaffold, taking a break from their hard physical toil. This treatment of working-class women is unusual for Sander, focusing as he did almost exclusively on men in the traditional manual crafts.

Sander planned to devote an entire section of "Citizens of the Twentieth Century" to "The Craftsman." It was to contain four portfolios with photographs of the master artisan, the industrialist, the worker, and the technician. It is noteworthy that Sander did not visit the large industrial plants in or near Cologne or in the adjacent Ruhr area, all but excluding members of the German proletariat from his typological catalogue. Also conspicuously absent is the recently introduced conveyor belt, a remarkable historical omission that hints at the photographer's bias toward manual means of production. His marginalization of modern industries stands in sharp contrast to the actual stage of economic development in Germany at the time. It reveals Sander's reluctant embrace of modernity as a powerful ideological undercurrent of his project.

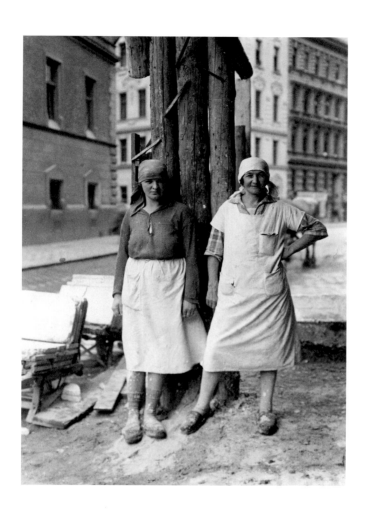

PLATE 31

Dockworkers

1929

Gelatin silver print
22 × 17.4 cm
84.XM.126.136

The section on "The Craftsman" was a highly fluid and amorphous construct. It contained many different occupations that did not easily fit a narrow artisanal definition. If Sander photographed industrial workers at all, he chose to represent them in ways that obscured their actual role within the German economy. A case in point is this portrait of a group of dockworkers standing in front of a brick building. A foreman, dressed in a white shirt and dark suit, is surrounded by his men in their occupational garb. The picture evokes time-honored guild ideals. It shows the men in their working environment, projecting a high level of professional satisfaction and pride in their labor.

Dockers in Weimar Germany, however, belonged to the great pool of proletarian workers. As such, they had very little in common with their counterparts in the traditional crafts. They did not own the tools of their trade, and their products were the result of divided, industrial labor. As Allan

Sekula points out in *Fish Story* (1995), working conditions in Weimar naval yards were poor and gave rise to numerous militant uprisings. In 1923 a strike of sailors and longshoremen in Hamburg had led to a violent revolt that prompted one contemporary observer to claim in a 1924 issue of the *Communist International* that "the Hamburg fights furnish a superb lesson of the classical revolution, as it will eventually take its course in Germany."

The rebellious spirit emanating from the waterfront was duly noted by members of the German middle class, the audience at which Sander's larger project was directed. While he certainly sympathized with the political demands of the proletariat, due in part to his son Erich's committed membership in the Communist Party, Sander nevertheless remained distant from its more radical goals. In this image he lends his subjects a surprisingly inoffensive air, thus distracting from any mutinous ambitions that they might harbor.

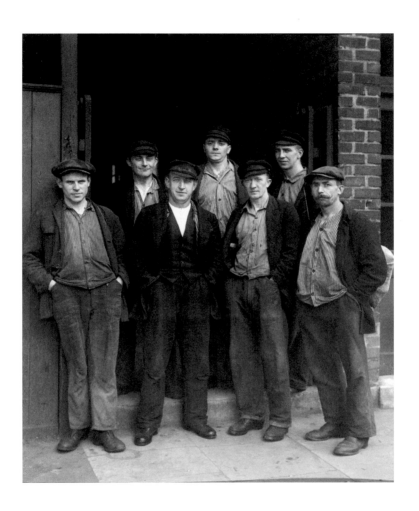

It is not exactly clear when the notion of physiognomy entered Sander's thinking or how rigid a system he actually followed. The idea consistently runs through his commentary on his photographs and dominated the critical reception of *Face of the Time* in the late 1920s and early 1930s.

During antiquity and the Middle Ages, physiognomy was a mostly speculative and intuitive discipline concerned with the understanding of bodily appearances and their relationship to the mind. The field gained semiscientific status in the eighteenth and nineteenth centuries, primarily due to the efforts of Johann Kaspar Lavater, Georg Christoph Lichtenberg, Franz Joseph Gall, and Charles Darwin. Lavater, in particular, worked to establish a classificatory method that allowed him to draw scientific conclusions from what he saw in the faces of others. During the Weimar years physiognomy's positivist stance and ability to high-

light differences was of particular relevance for a society in search of order. Following the loss of World War I, the dissolution of the Wilhelmine empire, and the threat of revolution, Sander's pictorial taxonomy was one of many contemporary attempts to grasp a social reality that was moving exceedingly beyond control.

As the market for physiognomic photographs in Germany flourished, Sander frequently printed details of larger compositions, showcasing his subjects' features. This is demonstrated by the picture of two blacksmiths (pl. 33) and a close-up from that image (pl. 34). The portrait of a mason (pl. 32) is another such example from Sander's oeuvre. It is likely that he created these enlargements for sale to commercial picture agencies, thereby taking advantage of an economic constellation that promised additional income from his work.

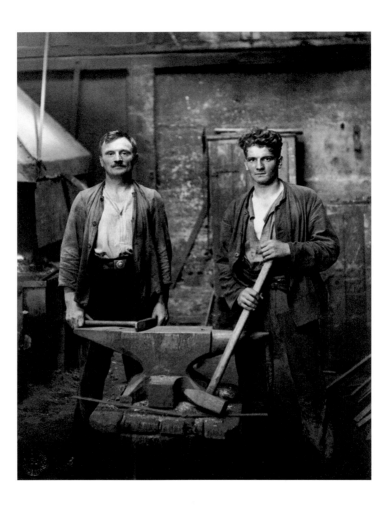

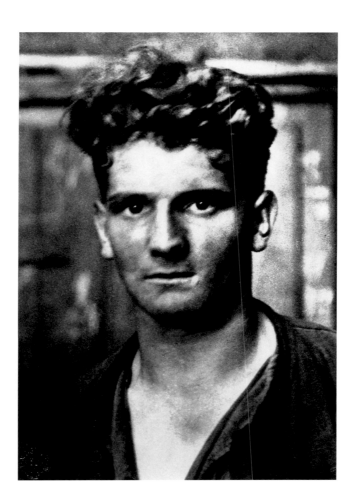

PLATE 35

Taxi Driver

1929

Gelatin silver print
21.9 × 15.9 cm
84.XM.126.120

"More than anything, physiognomy means an understanding of human nature," Sander observed in a radio lecture delivered in 1931. "We know that people are formed by light and air, their inherited traits, and their actions, and we recognize people and distinguish one from another by their appearance. We can tell from appearance the work someone does or does not do; we can read in his face whether he is happy or troubled, for life unavoidably leaves its trace there."

In 1929 Sander made this photograph of a taxi driver. He extracted the image from a larger composition, nearly filling the frame with his subject. According to the laws of physiognomy, every detail of the man's appearance is to be carefully read and interpreted: his tweed knickerbockers, the short sleeves of his worn jacket, his Chaplinesque mustache and intelligent gaze, and the soft flesh of his hand and face. The white button on his lapel suggests membership in a union or club—an important signifier of political orientation and social standing.

Equally evocative is the relationship of the man's body to the space surrounding it. By tightly inscribing his subject into the frame of his vehicle, Sander creates an image of almost claustrophobic intensity. It is suggestive, perhaps, of the driver's entrapment in a narrow, limited world. His occupational posture not only locates and interprets him, it also dictates the parameters of his photographic representation.

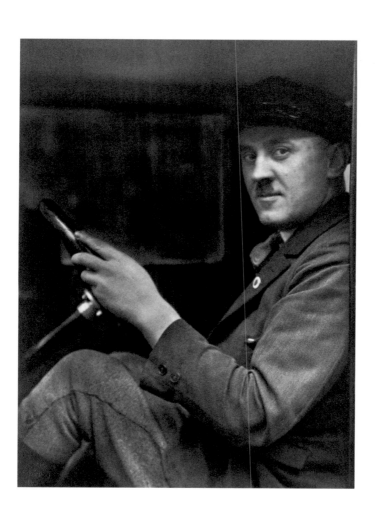

PLATE 36

Young Girl in a Carnival Wagon, Düren

1929

Gelatin silver print
29.4 × 22.8 cm
84.XM.126.223

Under the general rubric of "The City," Sander planned to devote two portfolios to "Traveling People." It was to include portraits of circus performers, carnival vendors, gypsies, and other itinerants—people on the fringes of society. Sander, despite his conservative position, showed considerable sympathy and understanding of such individuals. "This is a class of people which, with a few exceptions, now belongs to the past," he remarked about the portfolio (cited in *August Sander: "In Photography There Are No Unexplained Shadows"* [1994]). "It is very interesting to talk to these people: one learns a great deal about their circumstances and the deeper meaning of their lives. I wish to give neither a critique nor a description of these people, but only to create a piece of contemporary history with my pictures, a little romance in a materialistic age."

In this photograph of a young girl from the fairgrounds, Sander frames her delicate face against the grimy facade of a carnival wagon. By doing so, he immediately identifies her as a social outcast—a marginal type whose innocent expression strangely belies her seedy milieu. Through the open window in the door she holds the key in the outside lock and meets the camera with a dreamy, melancholy look. Behind her lies a world that is dark and inaccessible to the viewer. A suggestive, almost tantalizing narrative unfolds: of freedom and confinement, security and danger, things visible and hidden. Here physiognomy reveals itself as a marker of boundaries, a way of defining social difference. By holding the key, the girl evokes the possibility of transgression, subtly challenging Sander's classificatory gaze.

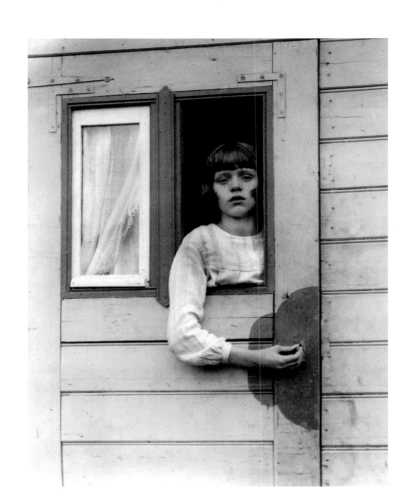

PLATE 37

Circus Usherettes
with Programs
Circa 1930–32

Gelatin silver print
23.6 × 17.7 cm
84.XM.498.14

In the early 1930s Sander made several
images of traveling circus folk, depicting
them sitting on the steps of their brightly
colored wagons or resting in between
performances next to the big top (see p. 129).
The entertainers' heavy makeup, rhinestone
costumes, and casual demeanor provide
a welcome reprieve from the regime of
middle-class propriety laid out in the earlier
portfolios. Here a pair of circus usherettes
pose for the photographer in their uniforms
and pillbox hats, presenting their program
leaflets like vocational IDs. Sander elegantly
renders their different poses, gestures, and
body types against the two-toned wooden
backdrop. The women confront the camera
self-confidently and without false pretense,
proudly advertising the Circus Barum.

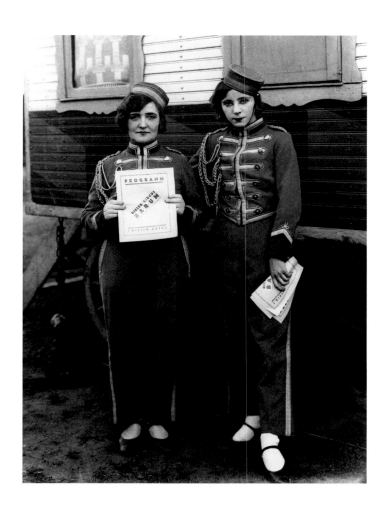

PLATE 38

Heinrich Hoerle
at a Carnival

Circa 1930

Gelatin silver print
28.2 × 11.7 cm
84.XM.152.158

The Cologne Mardi Gras, a season of merrymaking and feasting just before Lent, is one of the most famous carnivals in Germany. During three days in February the city turns topsy-turvy with civic festivities, parades with floats and brass bands, and people in bawdy masquerade celebrating late into the night. In Cologne and throughout the Rhineland, the Feast of Fools was prime time for commercial photographers, who extracted significant amounts of money from their costumed clients.

As Sander's son Gunther remembered, the parties given by the progressive artists were considered highlights of the Cologne carnival season. Sander became legendary at these events, making hundreds of pictures of the intellectual and artistic elite in their getups. This image shows the painter Heinrich Hoerle (1895–1936), an influential member of the Cologne Progressives and a close friend of Sander's. Throughout the night, a steady flow of patrons would approach the small stage where Sander had set up his camera. He retouched the glass-plate negatives later, numbering them carefully to avoid confusion. The long exposure required by his antiquated equipment often led to accidents, however, such as the blurred movement of Hoerle's gloved hands. This mistake lends the image a fresh and spontaneous feeling that quite befits the casual, celebratory scene.

Sander added some of the prints from the Cologne events to "Citizens of the Twentieth Century" in a portfolio devoted to "Festivities." Almost exclusively, it contained pictures of young artists in imaginative makeup and costumes. Their wild, funny performances push to the limit the idea of role-playing and social masquerade, pointing to gesture and movement as central ingredients of portrait photography.

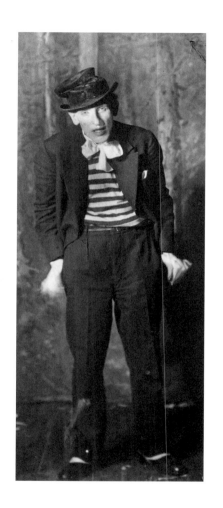

PLATE 39

Victim of an Explosion

Circa 1930

Gelatin silver print
28.7 × 22.1 cm
84.XM.126.201

It has often been stated that one of the strengths of Sander's art is the fact that almost all of his sitters make eye contact with the camera. By looking, they enter into a dialogue with the photographer and, by extension, with the viewer. Their ability to return the observer's gaze seems intricately linked to their completeness as human beings and successful functioning within the social system. By contrast, in Sander's portfolio on "The Last People," direct eye contact is rarely established. Most of the subjects—the unemployed at a street corner, the war veteran, a dead peasant woman, the blind, the maimed, and the mentally ill—either cannot see or have averted their gaze in shame. Their inability to communicate with their eyes is haunting and underscores their status as social outcasts.

Included in the portfolio is this portrait of an older woman, the victim of an explosion. Her damaged eyes are hidden behind dark goggles, her facial features erased by the ravages of fire. One does not know whether she can see the photographer; her glasses bar the viewer from any meaningful contact with her. Within Sander's system she is but an empty cipher—a sad freak, stripped of her ability to project her aspirations and self-image for the camera. What more can she expect from her portrait session but a photographic record that she once existed?

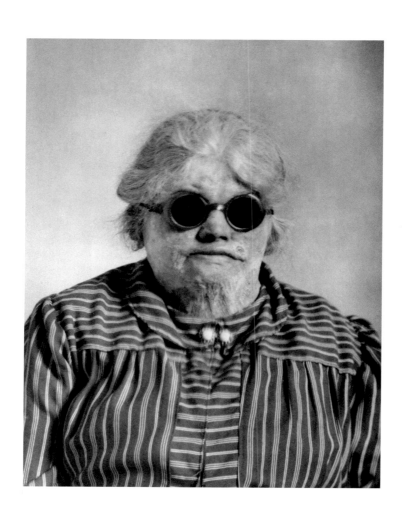

PLATE 40

Blind Children, Düren

Circa 1921

Gelatin silver print
23.4 × 16.9 cm
84.XM.126.107

In the early 1920s Sander made a series of photographs in a home for the blind in Düren, southwest of Cologne. Gabriele Conrath-Scholl has suggested that this might have been commissioned work, intended to raise money or recognition for the institution. The images show the children and young adults in the context of their daily setting, without visual praise or criticism. Here, Sander's naturalism works against traditional notions of medical photography, as it was practiced, for example, by Hugh Welch Diamond (1809–86) and other nineteenth-century documentarians of such asylums. Rather than highlighting the pathology of the blind children, Sander focuses instead on their common humanity.

This full-length portrait of two adolescent girls was made about 1921. Unable to see, they face the camera in a vague imitation of traditional posing principles. The incredible interlocking of their hands is the emotional center of the image—their warm, comforting touch creates an innate empathetic response that elevates the picture to a poignant humanistic statement. The girls' lack of vision is almost compensated for by the intensity of their embrace.

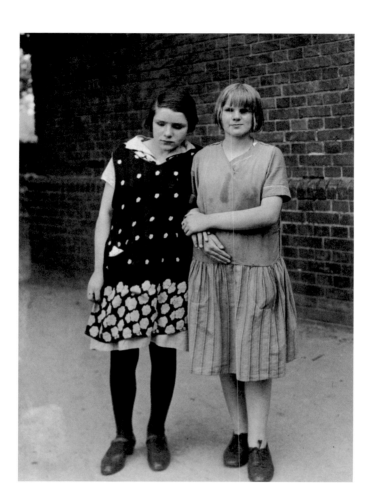

PLATE 41

Gypsy

Circa 1932

Gelatin silver print
27.5 × 21.1 cm
84.XM.498.6

In this picture Sander captures a young
gypsy standing in an empty country lane
with his hat in hand. The photographer
made the exposure with the lens set at
a wide opening, causing the background
to drop out of focus and creating the
impression of a painted stage set in front
of which the subject appears. The image
possesses an artificial, almost dreamlike
quality. The man's soft, curvilinear posture
and weary gaze add to a feeling of melan-
choly anticipation. The photograph was
made about 1932; the knowledge that the
reign of National Socialism, which almost
erased the gypsy tribes from the face of
Europe, was to begin in less than a year
lends the scene a quiet intensity—an
uneasy premonition of suffering to come.

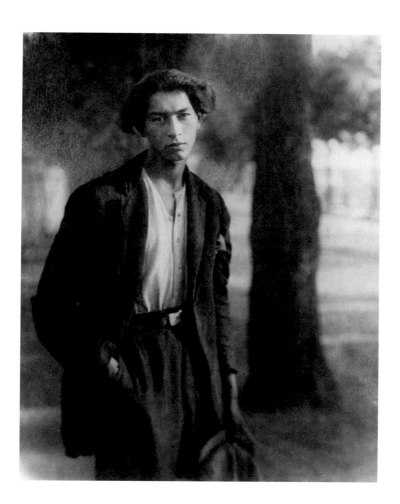

PLATE 42

SS Storm Trooper Chief

1937

Gelatin silver print
28.5 × 20.1 cm
84.XM.126.258

In the late 1920s and early 1930s Sander was at the height of his career. The publication of *Face of the Time* in 1929 and his radio lectures on the nature and development of photography in 1931 had established him as one of the preeminent German photographers of his day. The National Socialist takeover in 1933 put a dramatic end to his creative ambitions, however. His son Erich was arrested for Communist activities that year and sentenced to ten years in prison in 1934. Sander himself came under intense Nazi scrutiny for having aided Erich in the reproduction of Leftist leaflets. In 1936 the Reich Chamber of Visual Arts ordered the halftone plates of *Face of the Time* destroyed and all copies of the book seized.

Given these circumstances, it is all the more surprising that Sander in 1937 created this picture of an SS officer in Cologne. The image was made at the central train station, with the city's famous neo-Gothic cathedral as a backdrop. As in most of Sander's portraits, there is no detectable criticism, no sense of the photographer indicting the brutal politics this man represented. On the contrary, the cathedral in the background, a poignant symbol of German identity, lends the soldier a nobility and legitimacy that is reminiscent of Sander's best work from the Westerwald.

Like many of his fellow countrymen, Sander may not have realized what horrendous crimes the Nazis were capable of committing. He photographed the SS chief as if the man were just another specimen in his typological catalogue. The extent of Sander's political naïveté revealed in this picture is stunning, matched only by the intensity of his desire to record his country as objectively and truthfully as his medium would permit.

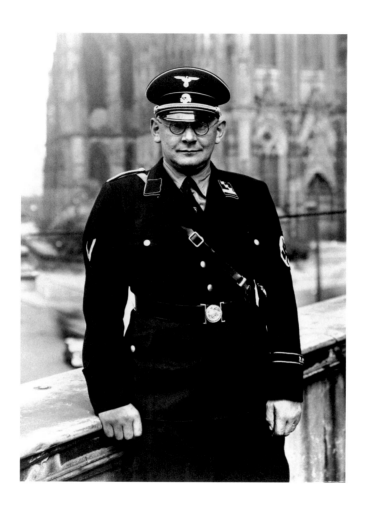

PLATE 43

National Socialists, Cologne Central Train Station

1937

Gelatin silver print
17.2 × 23.4 cm
85.XM.402

The same day Sander created the portrait of the SS chief (pl. 42), he also made this image of the officer posing with a group of men and women inside Cologne's central train station, its landmark advertisement of "4711 Kölnisch Wasser" hovering in the background. Some of the men appear in their brown SS uniforms and red armbands, while others, including a handful of women, are sporting swastikas on lapel buttons and official caps. Soldiers and civilians alike are smiling into the camera as if en route to a company picnic or on a weekend outing with their leader.

As Sander Gilman and Hilla Becher have pointed out, Cologne was a "Brown," or Nazi, city. Unlike Berlin, whose population and elected officials were mostly liberal, Cologne's conservative, predominantly Catho-lic citizenry strongly supported the National Socialists. It is not known how Sander came to create this image, whether he just happened on the scene while scouting for pictures, or whether he was specifically commissioned to document the event. What is seen in the photograph, however, is revealing. It shows what was basically a commonplace occurrence in Cologne and other German cities at the time: the Nazi embedded in his society, posing among his cohorts.

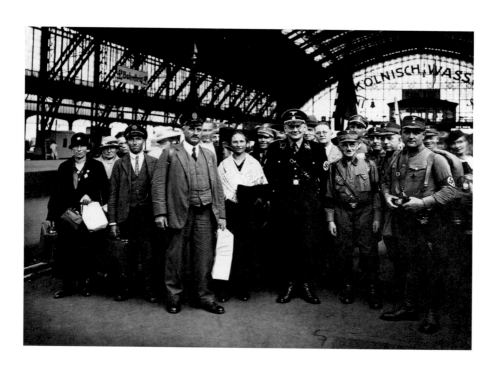

PLATE 44

Persecuted Jew

Circa 1938

Gelatin silver print
27.1 × 21.5 cm
84.XM.126.245

Influenced by political developments in Germany in the 1930s, Sander added two portfolios to the original set of forty-five in "Citizens of the Twentieth Century": the Nazi and the Jew. Grafting them onto the existing body of work, he left intact the solid, orderly, and respectable society outlined in the previous sections. As Ulrich Keller has observed, this rather simplistic juxtaposition of perpetrator and victim is a historic fallacy that implies that the rest of German society had little to do with the dramatic and unfortunate turn of events. Rather than acknowledging the deep social and cultural roots of National Socialism, Sander wrongly suggested that it was only skin-deep.

Sander and his family were sympathetic to the Jewish people. He and his wife, Anna, blatantly patronized Jewish merchants, even at a time when to do so carried serious risks. Many Jews, such as the young woman depicted in this photograph, came to Sander's studio to have their passport pictures taken, as they were trying to leave the country. For the artist, these photographs served a dual function: they were commissioned portraits that he later used for his own typological purposes. In either case, they represent a solemn record of the impending victimization of the German Jews.

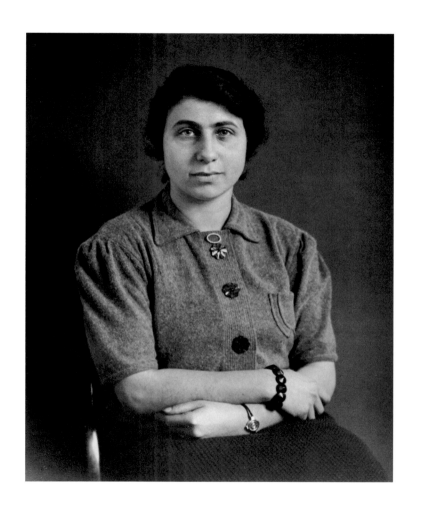

PLATE 45

**Freeway Built
during the Third Reich,
Neanderthal**

Circa 1936

Gelatin silver print
17 × 23 cm
84.XM.152.146

Around 1936 Sander captured this sweeping vista of the newly completed *Reichsautobahn* near the Neanderthal, northeast of Cologne. A typed label attached to the print suggests that it may have been intended for use by a commercial picture agency. The photograph is virtually indistinguishable from other laudatory depictions of the German autobahn, hailing it as a great technological achievement, a grand, dominating gesture across the land.

This image once again raises the question of Sander's association with a political regime from which he had very little, if anything, to expect. It is not known whether photographs such as this were made simply as a source of income or whether Sander created them on his own initiative, hoping to use them for his own artistic ends. What- ever its purpose, the picture radiates a political significance that can be reconciled with Sander's other work only with great difficulty. It may simply be one more piece of evidence that he collected in pursuit of the spirit of the time.

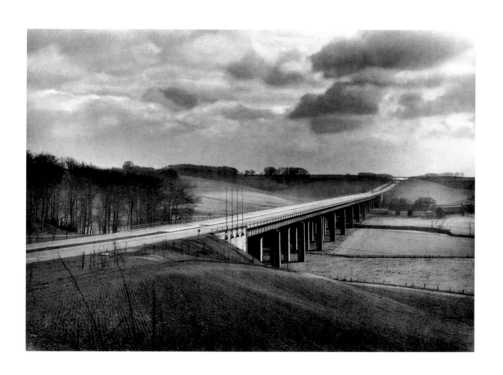

PLATE 46

Forest

Circa 1930–40

Gelatin silver print
22.7 × 17.3 cm
84.XM.152.129

By the late 1930s Sander's career as a professional photographer was basically over. No official explanation had ever been given of why *Face of the Time* had been confiscated, but it is likely that the book represented too complex and ambiguous a picture of German society than was acceptable to Nazi ideologues. As early as 1929 a critic from the Far Right had dismissed the book as "a physiognomic document of anarchy, of inferior instincts and of indiscriminate greed, rather than a document of uplift, enthusiasm, let alone essence."

Now in his early sixties, Sander spent most of his time reprinting and rearranging old negatives and making pictures in the countryside. He traveled along the Rhine and into the Siebengebirge, detecting in the gently sloping hills the same human spirit he had already documented in the faces of his contemporaries. "Like language," he had observed in a radio lecture in 1931, "[landscape] is stamped by man and his work. . . . The landscape, confined by the boundaries of a common language, yields the physiognomical time exposure of a nation."

The dense, impenetrable thicket of foliage in this photograph may be indicative of the confusion and disillusionment Sander may have felt at this time in his life. While he had been making images of the Rhineland since the early 1920s, he now focused his attention almost exclusively on landscape photography. Like many other artists of the time, Sander remained in Germany but was unable to continue the politically sensitive portrait work that was his passion. He shared this fate with the painter Otto Dix, who told the art historian Hans Kinkel in 1961: "I painted landscapes. That was tantamount to emigration."

PLATE 47

August Sander's Studio/Home, Cologne: Workroom

Circa 1930–42

Gelatin silver print
22.5 × 16.6 cm
84.XM.152.186

On September 1, 1939, World War II broke out. Sander and his wife gradually moved their belongings to the safety of Kuchhausen, a small village in the Westerwald, to avoid food rationing and the threat of Allied bombs. In 1944 their son Erich fell ill in prison and died shortly thereafter of "unknown causes." During the same year, the Cologne apartment was completely destroyed in an air raid. Sander's forty thousand negatives survived the war, having been stored in the Cologne basement, but all but ten thousand of them were subsequently lost in a fire.

Before the move to Kuchhausen, Sander created an album of photographs documenting his household and studio in Cologne-Lindenthal. Carefully mapping room after room, he recorded what he feared to be on the brink of destruction. The image reproduced here represents a corner of his workroom. It is filled with mementos of a life gone by. On the walls are two of Sander's portraits of his close friends Franz Wilhelm Seiwert (1894–1933) and Heinrich Hoerle,

members of the Cologne Progressives. Below an old-fashioned peasant clock hangs a photograph Sander had taken as a youth in the San Fernando mine. On the right, above a small built-in cabinet and two silhouettes, is an oil painting by Seiwert from 1923. A set of triangles and a T square are suspended from the wall above the stove. Next to the door frame, Sander's cat naps comfortably on a small, wooden chest.

Far from being a simple inventory of possessions, this photograph can be seen as a page in Sander's emotional autobiography. It traces his story from the mines near Herdorf to the sophisticated avant-garde circles of Cologne. Oscillating as it does between tradition, represented by the peasant clock, and innovation, suggested by the graphic design tools, the photograph acknowledges intellectual debts and celebrates friendships enjoyed. It is a document of melancholy introspection and commemoration, a physiognomy of the self, created at a time of great danger and uncertainty.

Portrait of a People:
The Photographs of August Sander

Weston Naef: To begin our conversation on August Sander, I'd like to make an observation about his early history. I've always been fascinated by his somewhat improbable transition from being a member of a working-class mining community to being an upper-middle-class consumer of art and culture. The image he presented throughout his life was one of the artiste, dressing in a beret and surrounding himself in his home with antiques. It seems somewhat incongruous that a man with a mining background should end up as an artist. Is the usual story of his upbringing true or are we dealing with some fictional elements in his early biography?

Gabriele Conrath-Scholl: Perhaps I can clarify this. Sander himself was not a miner, but from age fourteen until around age twenty, when he went to Trier to serve in the military, he worked with other young people on the ground level, above the mine. In the Siegen area of Germany, you can't really talk about a proletariat. It was a very different society. Up to the middle of the nineteenth century the area was independent; it was a community of steelmakers and miners who worked in a cooperative way. Two hundred years earlier the ruler of the region had been William of Orange, but because of financial problems he had to sell the hunting, fishing, forestry, and mining rights that the nobility normally held. The local residents bought the mining rights and also the forestry rights, which were the most important, since charcoal was needed for making steel. These people had a level of self-regulation that no other community in Germany had. They brought the management of the forest

into the families, and almost every family profited and participated in this business. They were very independent; for a long time they had not been dependent on any land law or company.

WN: This is very illuminating. What you're describing is how this little district was important for the wealth that it produced, but that this wealth appears to have been shared by the people who actually lived there.

Sander Gilman: By the families.

WN: What we're dealing with is a tradition where independence is as important as serving. The miners are part owners or profit sharers in the system. I have always had a difficult time understanding the biography of Sander because I didn't know the history of the area.

GC: I should go on, because we have yet to come to his time.

SG: Weren't these families also part-time farmers?

GC: Yes, *Selbstversorger*—autonomous farmers. But let me approach this the other way around. In the mid-1800s the best steel in Europe was made in the Siegen area; a special quality of iron ore was mined there, and the steel was still made with charcoal because of transportation problems. The mass production of steel using coal took place in the Ruhr district. The moment the railroad was built, however, it was easy to get coal to the iron ore in the Siegen area. The big companies flooded in, but they had to buy the land and the rights from the people, who got enough money so that everybody could build a house. It is unusual in Germany that workers owned their own homes and property; you wouldn't have that in the Ruhr area. They also had their own agriculture to produce food; they were self-sufficient to a large degree and totally independent of their employers.

David Featherstone: Gabi's historical overview gives us an interesting backdrop with which to begin looking at Sander's photographs. We will view some images individually and others in pairs, which will give us the chance to make some comparisons. We'll begin with two untitled portraits, one of a woman, a gelatin silver print dated 1901–9 (p. 103), and another of a man, a gum bichromate print dated 1907 (p. 104).

August Sander.
Portrait of an Unidentified Woman, 1901–9. Gelatin silver print,
19.7 × 11 cm. 84.XM.152.43.

Hilla Becher: What is interesting to me in these pictures is that I see some things that are links to Sander's later career. In this very early phase of his work he already tended to clarify and to employ very simple methods. In the photograph of the woman, for example, he uses a plain background—there is no painted back-drop here—and he has the whole figure in the picture.

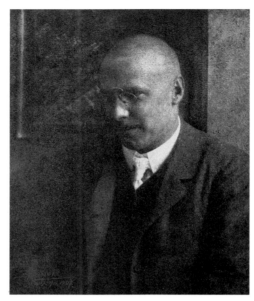

August Sander.
Portrait of an Unidentified Man, 1907. Gum bichromate print,
21.5 × 17.5 cm. 84.XM.126.157.

WN: That's true. Let's describe what we're seeing. In the portrait of the woman, she is standing in an identifiable room. The focus is sharp, although the resolution of the print itself is low because the light is very low. Stylistically, I would identify this image with the work of naturalistic photographers, who tried to capture a person's most typical expression. The smile is the typical smile of the subject; someone who knew the woman would say, "Oh, that's her."

In the man's portrait the focus is soft and the details are generalized and blurred. The context is generic and ill defined. We know it's architectural, but in comparison to the other image, where we can see wood wainscoting in a room that has a particular character, the architecture here is more abstracted. By virtue of the way this photograph has been manipulated—that is, the manner by which the details are suppressed by the gum bichromate process—the picture looks more like a drawing than a photograph. The word usually applied to photographs that are

made to look like other works of art is *pictorial*. The man in Germany who did more to advance this style than anybody else was Rudolf Dührkoop, who was a major portraitist of the time. It would seem to me that here Sander is not being an innovator; he is following an existing style.

GC: I am not very comfortable with the expression that he was a Pictorialist.

WN: What term would you use?

GC: He was a photographer. I think the man's portrait is quite an unusual picture for Sander. If you choose this as an example of his work at the time, then you are right, this is Pictorialism. There are certain elements Sander included that are purely pictorial, but a lot of his early works are more in the direction of a clearer view of things. What should be mentioned is that both styles are present, but even this early the way to the new direction can be seen.

HB: Couldn't one say that Sander tried some experiments like this, as any great photographer does in his lifetime, but that it wasn't very typical for him?

SG: I'm wondering whether or not we're doing something a bit retrospective in saying that Sander begins by thinking of himself as an artist. Gabi used the word *photographer*. I happen to agree with that. I think that to look at these early works, you must think of them as products of the photographic studio. The studio has a clientele, and a clientele has expectations; Sander's studio offered, like any other of the nineteenth or twentieth centuries, a wide range of potential styles and formats. I am very anxious about in retrospect aestheticizing these early images that are purely studio photographs, including the one described as Pictorialist.

WN: I disagree completely, because at the time that Sander made these pictures, he was trying to establish a reputation as what is called an "at-home" photographer. He went to the home, office, or garden of a client and tried his very best to make that person seem natural in his or her environment. In doing this, he was following in the footsteps of Gertrude Käsebier in New York and Dührkoop in Germany. The point I'm making is that we know he owned a studio, but he advertised himself as an "at-home" photographer, that is, he was prepared to travel.

Ulrich Keller: Let me explain something that happened around 1900 that profoundly affected the way in which photographers worked. The big commercial studios largely went bankrupt at that time because the lower end of the clientele, the mass clientele, no longer patronized them. People went to department stores and had pictures taken there for a fraction of the price that was charged in the studios. The other thing, of course, was the introduction of the Kodak camera in the 1880s; amateur photography came along, which again affected the lower end of the market. You took your own family pictures.

All this meant that around 1900 a lot of people, including Sander, changed styles and began to provide something to upper-middle-class clients—a personalized, intimate picture, often a gum bichromate print, that amateurs could not make with a Kodak camera and that you could not buy in a department store. There was still a market left for professionals, but if you wanted to survive, you had to go upscale. In Germany, that movement was particularly strong, but it had nothing to do with Dührkoop and Käsebier. There were other people who propagated this style; practically all the German commercial photographers subscribed to it, and it would be strange if Sander had not.

SG: You're saying something important, that it's a client's expectations that drive a photographer, not the other way around. It isn't that Sander suddenly decides, "Aha, this is art." It's that his clients say, "If you want to sell me a photo, it can't look like the Kodak product."

Joan Weinstein: In German art journals of the time the primary interest was in the commercial style of Pictorialism. Photography is discussed in terms of the technology and its adequacy for Pictorialist ambitions. There are small sections of journals like *Kunst für Alle* that talk about fine art photography, but the interest seems to end there, even in the most progressive art magazines of the time.

SG: The reality is that the economics of photography in Germany was very different from that in the United States, especially after World War I.

WN: Can you explain the nature of that difference?

HB: To reduce it to essentials, the difference is that photography in Germany was part of the trades. You became an apprentice, and then a master. This was regulated in a very strict way. It was the same kind of procedure for a blacksmith. Even if somebody like Sander didn't actually do this kind of apprenticeship, he still was considered a craftsman. If you were apprenticed, you not only learned how to handle a camera and to develop the film, you also learned how to position a subject's hand, turn the face, and tilt the shoulders. I did this kind of apprenticeship in the old-fashioned way, just like in the nineteenth century. After three years, you have to take your exam, and you are asked to make one portrait, one double portrait, one still life, one landscape, one architectural study, and so on. You have to make a portfolio, and then in the end you can say, "I am a journeyman!"

WN: What you've just described is classic academic training, whether it's for a painter, sculptor, or physician. But what is the ingredient that gives Sander such distinction later on that is missing at this point? When you describe him as being a product of the traditional educational process, it still has to be explained how someone who was not supposed to invent new ways of photographing made the leap to create a body of work that is exceptional in the history of art. He was supposed to satisfy his clients by repeating what he had been taught. And suddenly, at some point, he did something that broke completely away from the tradition that he had come out of and created an entirely new way of making a portrait.

SG: One of the reasons you can link photography and medicine is that these are free professions. That is, they are professions where you enter into the apprenticeship system but where upward mobility is possible because you are self-employed. In Germany, the idea of upward mobility was tied to a notion of educational refinement and aestheticism beginning in the 1880s; "the beautiful" becomes part of what free professions provide.

UK: Another fact that should be remembered here is that we are dealing with questions of aesthetic reform that came out of England and took root in Germany, where photography developed very differently than in America. Alfred Lichtwark, who was a major figure in Germany at the time, initiated the Pictorial photography movement there as a nonelitist amateur movement. It was supposed to infuse the

art world with new vigor, but Lichtwark also aimed to reform the whole of society aesthetically, including the professional sector. The commercial photographic sector, of course, was not particularly aesthetic; these photographers were thought to be makers of very stereotyped, run-of-the-mill images. So from the beginning, the Pictorial amateur movement in Germany was supposed to reform the commercial sector, and even society at large.

DF: Perhaps we can continue our consideration of Sander's early photography by looking at two pictures he made after establishing his studio in Cologne: *Peasant Woman of the Westerwald* (pl. 1), from 1912, and *Shepherd* (pl. 2), from 1913.

WN: I am a great believer in the concept of genius. I think that everything in the world worth having is the product of some genius. The first two pictures that we looked at show no promise whatsoever of this for Sander. If I saw them on display, I would not imagine that the person who made them went on to change the way we think of the art of photography. By contrast, I think these two portraits from the Westerwald are works of incipient genius. They are so wonderfully realized, so perfectly seen compared to what we looked at before. The intervening years somehow resulted in incredible growth. When does the spark of genius begin to show itself? When does Sander break away from something that was a pitiful concession to existing practices and standards and merely a way to make money?

Claudia Bohn-Spector: I wonder if this notion of genius really contributes to our understanding of what these pictures mean.

WN: It doesn't at all. The designation of genius only comes after the body of work has been created. It's a conclusion, not an interpretive tool.

HB: Yes, it's a term like *beauty.*

WN: Right. But not every artist has genius.

HB: Why are you reaching that high? It could be that Sander simply found his special ability. There have been thousands of really good twentieth-century portrait photographers, but Sander was different from them. He had a similar craft, but I think he was different because he got very close to essentials. That's partly, of course,

because he grew up in such an unusual situation. Herdorf was a booming industrial town experiencing something like a gold rush. Normally the village had about three thousand inhabitants, but during Sander's youth there were ten to twelve thousand people living there. Workers from all over Europe were present, including Russians, Italians, and Poles in great numbers. Sander saw so many different faces and personalities during his childhood that he became interested in people, and he later made something of this.

CB: But what is interesting to me is that, with some exceptions, he didn't photograph the differences. He photographed Germans.

SG: One has to say that these images have a double function. The initial purpose was commercial. In the second decade of the twentieth century Sander was going out and looking for clients in the Westerwald. These were the same kind of people who had come into the Siegen area as day laborers in the 1880s and 1890s; he was already connected to them and knew that they had the money to purchase photographs.

 The second function of these pictures comes in the 1920s, when Sander, like dozens—I would even argue hundreds—of photographers, started to look at physiognomy as a means of classification. The big literary event of the 1880s and 1890s was Wilhelm Riehl's creation, in about twenty-five novels, of a literary anthropology of the German tribes. It's exactly the equivalent of Balzac and Zola in Paris, except that rather than being urban, it was rural. These popular novels look at small-town Germany in terms of tribal identity and suggest a tribal ethic: you'd better be "us," not "them." In 1911 Oswald Spengler talked about the late nineteenth and early twentieth century as being the age of physiognomy.

DF: Can you tell us something about how these two photographs specifically relate to the idea of physiognomy?

SG: These are absolutely typical of the ethnological photographs of the 1880s and 1890s done in the Austro-Hungarian Empire and in Germany by ethnologists who went into exactly these same villages and took exactly these same pictures. The difference is that in them you would have had a meter staff in the photograph so that you could measure ear size, because ears were read for meaning. The eyes of both of these Sander subjects are like the examples represented in a table called "How

to Read Eyes" in Karl Huters's great physiognomy of 1904, *Knowing People (Menschenkentnisse)*.

WN: I think there's an important flaw in what you've just said, and I'd like to describe it. It first has to do with the issue of clientele. An ethnographic photograph is not created because the individual portrayed has commissioned the photographer. There is no need and no desire to please the client.

SG: Oh, certainly.

WN: But I would also like to raise the question of why a photograph such as this portrait of a peasant woman was made. In my family, all of the women, and even my own father, after they got to the age of about seventy, did not want to have their pictures taken. This woman is typical of every woman in the world who reaches that particular age. She is not going to commission Sander to make a portrait of her. It had to be made for some other reason.

SG: Perhaps the woman's family commissioned it. When I look at the picture, I see an old woman, but I also see a highly religious image of someone preparing to meet her maker, with Dürer's hands in prayer holding a Bible. It has a very different iconographic function in this family! And then what happened in the 1920s is that Sander went back and said, "All of these pictures I took, which have a very specific locus out in the country, now also have an ideological reading that says I can get back to the basis of this culture by looking at those people, who are uncontaminated by the city." I think that's really important.

JW: Getting back to your point that there is no difference between these photographs and the ethnographic ones taken in this period, are they similar in terms of pose, lighting, and dress?

SG: Absolutely. The notion was that you had to capture the reality of daily life. The subjects were oftentimes posed in profile and then turned full-forward and half-faced, so the ear was visible. Things like the shape of the nose and the ears were important.

JW: Are the images typically of individuals or of groups?

SG: They are almost always of individuals; sometimes you get family groups.

UK: I can see something in both of these pictures, especially the portrait of the woman, that in German you would call *Sachlichkeit*—objectivity. To that degree I see a certain relation to ethnographic photography, but at the same time I have my doubts about too close a relationship. What I think may have happened, on the level of business, was that Sander came to Cologne with his pictorialist style and his ambitions to break into the upscale market, but that did not work out, and he had to take his camera and trudge around in the countryside. That was a defeat for him. And then he made his first pictorialist portrait of a farmer, who said, "Take that away; this newfangled stuff is not for us." So Sander had to retool and do something different. Whether that is now ethnographic, I am not so sure. Certainly from the viewpoint of the farmers who taught him a new style, it was not; they were not their own ethnographers.

As Claudia said, Sander remains at a distance from this whole tribal idea because he never photographed a variety of different tribes and their costumes. His subjects form a relatively homogenous group with very little emphasis on costume and on local differentiation. When he talked about these people, he might use titles like "The Earthbound Woman" or "The Sage," but I don't think the context was ethnological.

SG: Let me repeat what I said though, which was that initially these photographs were taken exactly as you describe them, and that retrospectively, in the 1920s, Sander reprinted them as larger-format studio images when he went back into his archive. No, they're not initially called ethnographic photographs by him or anybody else, but later they become ethnographic proof. What is missing from his work, yet exists in all the other similar projects in the 1920s, is the attempt to document a full scale of all the tribes. The most interesting thing about Sander, I think, is that he didn't try to complete his notion of the tribes, but rather went back into his own archive and reread that.

CB: Sander went out to the Westerwald and built his portrait work there and at the same time developed his clientele in Cologne, still practicing the pictorialist style until the beginning of the 1920s. He really had two styles existing simultaneously.

When did Sander decide that the style of the Westerwald images was where his work was going? Did he make this decision in the early 1920s, when he met the Cologne Progressives, and all of a sudden saw something that he hadn't seen before? I am reminded of Alfred Stieglitz's *The Steerage*. This famous picture was taken in 1907, but I don't think anybody, including Stieglitz, recognized its significance until years later.

DF: Maybe we should move our discussion to what, in Weston's opinion, is the equivalent for Sander of *The Steerage*, the portrait of the three young men, titled *Young Farmers* (pl. 5). It was made about 1914 and is one of Sander's best-known photographs. But what exactly does it depict?

GC: This shows three men going to a dance. I know this from an interview I did with a friend of the one on the right. The picture was taken somewhere between Dünebusch and Hallscheid, in the Westerwald. The farmers were on their way to a dance on a Saturday, and they met Sander by accident. The photograph was made in the summer of 1914, before World War I broke out.

SG: I have to agree with Weston that this is the pivotal work. I have always read it as a kind of *Las Meninas* image, referring to the famous Velázquez painting. It reflects on the presence of the artist in the image. It is unlike staged photographs, which have the illusion of action. This shows people on their way to a dance who just happen to be stopped by a photographer, who takes their picture while he is being looked at. This is not a naturalistic image at all; the men would not have stopped and looked had Sander not been there.

WN: Coming back to the question of clientele and motivation, who was this picture made for and why?

GC: I think it is important to understand that Sander was well known in that region as the photographer from Cologne who took pictures of almost every family in the small villages. These people knew each other very well; many of them were relatives. They talked about Sander and his photographs and they loved to give them as presents to each other. In this way Sander became known as a craftsman in the region whose work was appreciated. So the three young farmers knew Sander from their everyday life and were confident that he would photograph them well.

112

WN: My understanding of Sander is that he needed money to support his family, but I have a hard time imagining these three young men paying him to make this photograph.

GC: Everything in Sander's career is very fluid. Not every picture was done with that commercial motivation, but the negative's inscription gives us a hint that this image was sold to these people. The names and negative number are noted on the edge of the plate, just like on his commercial work and that for "Citizens of the Twentieth Century."

WN: How did the picture come into being? How did Sander manage to get the men to stop?

GC: He went through these little villages on foot or by bicycle; it is very common to meet people walking through a village.

JW: What makes the image so wonderful and so pregnant with meaning is their dressing up. You do not see where they are going, but with their clothing, the dangling cigarette, the walking sticks, the poses, the looks, there's an imitation of a city attitude.

SG: They are flaneurs in the country.

JW: The setting is what makes the image so compelling.

CB: It's more than the setting. I think there is something about the time in this picture. This is a mixture of a snapshot and a formal portrait.

JW: Yes, it's something spontaneous yet not spontaneous. They are posing, yet they are taken aback.

SG: It's also the fact that, unlike the studio photographs we just saw, in which the photographer disappears and we take his place, here the artist is present. I think that's really important. I think Weston is right; this really is a seminal moment for Sander, because it is when he realizes he can do something slightly greater in the actual first-stage photograph, not in the retrospective sense of twenty years later, but in the actual taking of the picture. And that is something greater than his contemporaries had been able to do. The *Steerage* analogy is a very powerful one.

UK: I would agree that Sander the observer is born here, because he has done something that is outside the professional routine. The previous images we have seen can be explained in that way; this one cannot. Clearly the subjects interest him enough to say, "I'll make a picture right here where I've met them," but there is also a second aspect. You could say that Sander emerges here as an unusual photographer because this is a relative picture, one you don't fully understand unless you remember the others he's done before. The serial, comparative photographer is born here, because you don't get the point of the picture if you don't remember that these men's parents were the very traditional, severe-looking people with the Bibles in their hands who wouldn't have been found dead with this cigarette. Here, Sander banks on our knowledge of his other images.

This serial, comparative, and sociological work I can't reconcile with ethnology at all. No ethnologist would have come close to taking this picture. For one thing, there is too much respect; I can believe that he knew these people. Sander made many other photographs in which farmers, old and young, are not looked at as strange ethnological specimens, but as citizens, as actual people.

GC: Something else I think is very interesting in this picture is the movement of the men. Their poses are so similar, yet just one man is moving. I want to quote Sander from the fifth of the radio lectures he did in 1931. He said: "Not only a person's face, but his movements, define his character. It is always a photographer's responsibility to stabilize and record characteristic movement which will then express physiognomy in a single comprehensible image." This is, I think, what he did here.

SG: This is the distinction between fixed and mobile physiognomy, which was incredibly important in the nineteenth century. The eighteenth-century scientists studied fixed physiognomy, the notion of reading the shape of the nose, the skull, and so forth. When Darwin introduced the notion of a mobile physiognomy—the way you move in space as a definer of character—into the scientific discourse in the nineteenth century, it became very important. The distinction is a vital one. Fixed physiognomy you're born with; it can't be changed. Mobile physiognomy is the result of nurture, the way you live in the world. When you start to look at character that way, it's character being formed rather than a character you're born with.

JW: But isn't that a discourse Sander introduced in the 1920s, when he went back to this image? It's not something that was in his mind when he made this.

HB: I think he saw this right away; he met these people and said, "Oh, you were great just then. Turn around, look at me. No, a little more."

WN: I don't think this photograph could have been quite so candid, because he was not working with a hand-held camera. It was a stationary camera on a tripod; it had to be in position first. This is a completely posed photograph; he has structured everything.

HB: Yes, but he had them repeat what he had just seen them do. It's like in a movie; it's a second take.

SG: I want to say something about posing reflecting practice. You can see it in the walking sticks, which are all being held in the same way. That is the earmark of the flaneur; that is the way city slickers from the 1890s walked. One of the things Sander is doing here is giving us a reading of these country bumpkins dressed up as city folk. Even if he does like these people, this is a satire.

UK: But you have to remember that all these pictures are collaborations between the photographer and his clients, and I think that only makes them more powerful. If they hadn't collaborated, there would be an imposed irony, and it wouldn't work. These people have invested a lot of money in their new clothes; they are proud of themselves and are cooperating, and that's probably why they wanted a picture.

WN: To the best of my knowledge, there is not a single surviving first-state print of this image. This is an important point, because if this picture is all the things that we've talked about, why was there no early print?

GC: A lot of the pictures in "Citizens of the Twentieth Century" are commercial works, and for many we have no first-state prints. That is because Sander sold them to the clients, and they have them wherever they have them.

WN: But remember that one whole part of our collection, 350 photographs, was gathered from the families of the owners in this very neighborhood. If a picture as

good as this were sold or given to those three farmers, somebody from their families would surely recognize its value.

HB: Don't forget that two world wars happened and that the families may not have recognized it as we see it.

SG: Also remember the different function photographs had. They had very low status, even among peasants, as aesthetic objects. We know that prints had a higher status in this society. Religious prints especially, which cost much less than photographs, tended to get passed on in a family from generation to generation. Photographs quite often didn't.

DF: Let's move now to a pair of portraits made in the town of Ückertseifen, in the Westerwald. The first, of the Hähner family (pl. 10), is dated between 1910 and 1914, more or less contemporary with the portrait of the three young men we've just discussed. The other, of Mr. and Mrs. Schenk (pl. 12), is from 1926, about twelve years later.

GC: These are two different families from the same region. There has been some misunderstanding that the pictures show younger and older versions of the same couple, because the boy in the middle of the family portrait is also depicted in a 1926 photograph (pl. 11) in the same place where the Schenks posed.

UK: Isn't the Hähner family portrait from the Erwin Wörtelkamp collection?

WN: Yes.

UK: So this is the actual print that Sander originally sold in the Westerwald region.

GC: Yes.

UK: Although this is an original, it is not one that we can say was made for the projects that Sander is associated with. Neither of these pictures was culled from the archives to become part of "Citizens of the Twentieth Century."

GC: That's right. There are some very similar portraits and family groups in "Citizens of the Twentieth Century," but in a lot of cases it is very difficult to determine why Sander chose one picture over another.

UK: So in a sense the Hähner image is a rejected photograph. The family pictures in *Face of the Time* seem much more informative sociologically and interesting compositionally.

GC: One can say that this is an example of the usual commissioned works that Sander took in the Westerwald and that many comparable pictures were made and still exist.

WN: In comparison, the couple's portrait from twelve years later is a masterful photograph! Look at the way Sander has focused his attention on those two people, the way he's integrated that incredibly messy background. I find this just as good as anything else he did in that particular genre. I would have to say that the reason this one may not have been selected is purely chance. We know that in 1939 he had forty thousand negatives. That's a lot of material to go through in assembling his published projects.

GC: And both negatives still exist, so he could have selected it.

WN: Right. He had a lot of material to choose from and a finite amount of time and space to create his works. He probably had a number of interchangeable photographs. Let's imagine the art history of it. Imagine a Degas we've admired because of all the subtle details that make up the picture—the handwriting. For me, the portrait of the Schenks has all the handwriting of Sander—his sensibility and intelligence, the way he gave himself over to these unremarkable people. That is what makes me give myself over to the picture; it may not be the greatest work that he did, but it represents everything that he was capable of doing at that particular time.

SG: If you want to press an artistic analogy, I would see this more in the light of something like Grant Wood's *American Gothic,* which is also an evocation of a lost world. One of the things happening here, not for the people in the photograph and maybe not for Sander at the time, but certainly for him when he was working on "Citizens of the Twentieth Century," is the realization that this is the end of the society of which the old people are indicative. That idea is very much at the heart of the argument of *American Gothic,* which says, "This was the real America." Of course, it wasn't, but it was characteristic of an earlier period. There is a lot of that here.

CB: To me, there is always an element of melancholy in these pictures—they depict something that's on the verge of disappearing, something that needs to be captured and preserved.

SG: I would stress, though, that this was an ideological discussion in the mid-1920s, but that it was not factual. These small towns still exist, and so do the people.

JW: Knowing that it's 1926 makes an image like this especially interesting, because it almost has two functions. Such photographs could be taken and used in a project like *Face of the Time,* which created that reading of melancholy, but at the same time, Sander went into the countryside and took these photographs and made prints for people who still wanted this kind of portrait.

WN: That's an important element. He was still doing this; it wasn't as though the past had caught up with him.

CB: This idea of melancholy, of course, can come in different guises. One is to become sentimental about how these people are on the brink of disappearing, and the other is to focus instead on the potential of loss. The latter is what's going on here.

JW: It's about different audiences as well. Such pictures wouldn't be about melancholy or loss to clients who are being photographed and are going to hang the portraits in their homes, but when Sander includes the images in *Face of the Time* and directs the book to an urban, educated audience, the pictures have a very different connotation.

WN: For me, the portrait of the Schenks evokes not nostalgia or melancholy, but actually much more positive and dynamic elements. I see visualized the very abstract notions of integrity, respect, and pride.

SG: But then let's go on to the next step, which is that these are old people who have those qualities, and they are going to die. There is no next generation.

WN: No, that's not the point, in my opinion. In fact, the next generation is represented in the picture of the young man with his bride, which was made in the same location as this.

SG: So if the origin is the notion of potential loss, then the recuperation of the loss is by having the young married couple in the same setting.

WN: That's exactly it.

SG: It makes it melancholic, but with the promise of fulfillment.

DF: This next pair of photographs brings us from rural Germany into the city and to Sander's association with the Cologne Progressives. *Wife of the Cologne Painter Peter Abelen* (pl. 21) dates from 1926; *Bohème* (pl. 22), which depicts the artist Gottfried Brockmann, was made in 1922.

JW: The image of Abelen's wife is fascinating to me because I am very interested in the concept of the "new woman" in Weimar Germany. This was both a social reality and a social construct. Women were mobilized in the workforce in World War I, and many of them continued to work after the war. This created incredible anxieties about women's roles in German society, particularly about their ability to have children. The German media became obsessed with the image of the new woman, constructing her as masculinized and often depicting her in masculine garb, as in this picture.

SG: The concept of the new woman began before the war, when the notion of gender boundaries was conceived of as malleable. There was not simply male or female, but rather a spectrum of sexual identity running from male to female. After the war two things happened that further pushed these boundaries. In 1920 the first trans-gender surgery—a male-to-female surgery—was performed; in 1923, the biography of the best-known transsexual, a Danish artist by the name of Emil Hölder, became an international best-seller. Images such as the one of Abelen's wife were not simply about the new woman, but also about the whole idea of the absence of clear boundaries. The Left and the Right both had problems with this. There are a lot of politics in this picture—politics of body, politics of transformation, politics of society.

JW: What's interesting here, of course, is who the figure is: Helene Abelen, the wife of an artist in the Cologne Progressives. What is ironic is that the reader of *Face of the Time* saw this image of the new woman, but she was identified as the "wife of."

CB: What is actually happening in this photograph?

WN: I see this as a woman standing in an artist's studio or an art gallery surrounded by her husband's paintings. She is dressed in a sort of occupational costume, i.e., the stylish clothes that are fitting of her role as an artist's wife. She has a cigarette clenched between her teeth that she is going to light, and in her hands are the match and striker. For me, the picture is about the actuality that something is about to happen. There is a powerful sense that we're about to witness an explosion of some kind, yet we have to infer what it is that she is thinking, what that explosion may be.

SG: The act of smoking is present in both this picture and the one of Brockmann. If we read them in the context of the photograph of the three men on their way to the dance (pl. 5), it seems to me that the question of the act of smoking as gender performance is an incredibly important one. Brockmann may be seen as slightly effeminate because of his posture, but his smoking is a natural extension of his masculinity. With Abelen, the notion that here is the moment when the new woman is going to create herself in the act of smoking is a powerful one.

JW: One of the signs of the new woman was the dangling cigarette.

CB: I think that Brockmann's pose is very effeminate. He doesn't use the cigarette as a sign of his masculinity.

SG: But he doesn't dangle it.

CB: That's true. But his gesture is kind of enticing, almost lascivious. I think it's feminine.

WN: Doesn't the photograph of Abelen have aspects of physiognomy? Her flat-chestedness somehow seems to be intentionally created by corsetry or else was the standard of beauty.

JW: I think this addresses an interesting question of posing, of what went on when this picture was being made. It is instructive to compare this image with a Sander photograph of Helene with her child (p. 122). She is in different dress, but the picture may have been taken at the same time. It's in the same location, in the same cor-

ner, but there are additional paintings on the wall. This indicates an incredible self-consciousness in putting on the artist's costume and posing for Sander.

SG: Are you suggesting there's role-playing going on?

JW: Yes.

CB: The way she turns with an implicit motion of coming toward the photographer is very threatening.

HB: She's a femme fatale. The posture is the important thing in both photographs; it seems in opposition to the stereotypical Prussian bearing from before World War I.

SG: Now we're back to mobile physiognomy. We know that we can read something into the body, and that the body isn't fixed. She can become a mother in one picture and something else in the other. Her role is situational, cultural; it's not fixed.

WN: What about Sander's role in the creation of the photograph? Up to now we've been talking as though this image is exclusively the product of Abelen's projection, but it didn't come into being without Sander. Since we have these two pictures that show her looking somewhat different, how did he collaborate in the posing and the changing of the costumes? And where does the solo image fall within the body of Sander's work? If I didn't know he took it, I might think Edward Steichen made it for *Vogue* or *Vanity Fair*.

GC: I would agree that this picture is an exception in Sander's oeuvre, but it is also unique in that it is really a creation between three people. The costume was created by Peter Abelen. He designed clothing for his wife and also designed her haircut. It was his suggestion to do this photograph; it was done in their apartment with his paintings on the walls.

CB: Are you saying that this image was designed for her by her husband?

GC: He didn't design it for her, but her daughter told me: "This was the creation of my father. He wanted her to look like this. He always did our haircuts, he always did our dresses."

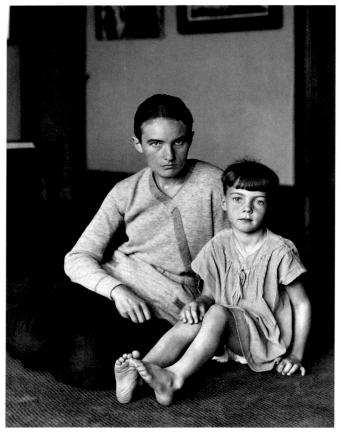

August Sander. *Mother and Daughter, Cologne,* circa 1926.
Gelatin silver print, 25.9 × 19.8 cm.
Collection of August Sander Archiv, Kulturstiftung Stadtsparkasse, Cologne.

UK: That confirms my thought that she's a product of the male gaze, just like Gabriele Münter, who wore garments designed by Kandinsky.

CB: So much for the new woman! Sander planned a section on women for "Citizens of the Twentieth Century," but none of them are identified by name. Most are seen in their roles as wives and mothers.

UK: It's true for the men, too. Sander doesn't give their names.

JW: Only the intellectuals are identified.

UK: Yes, but he didn't identify them in *Face of the Time,* which is the standard of his publications. We know the names of people who were intellectuals, but that doesn't mean he meant those names to be publicized in any way.

DF: The next two photographs—*Peasant Woman, Westerwald* (pl. 15) and *Peasant Woman, Sauerland* (pl. 16), continue the idea of Sander's involvement with physiognomy. Both were executed between 1910 and 1914.

WN: Let me interject, however, that although the negatives were made between 1910 and 1914, the prints we are looking at were created about 1930. We should consider them in the context of Sander's work of that period.

JW: Of the photographs we've looked at, these are most clearly about the issue of physiognomy.

GC: Sander did a lot of pictures like this, with a close-up of the head taken from the full negative. He has a group of perhaps thirty or forty cropped heads of farmers and farm women that he compared with each other.

WN: Let's clarify that these are small prints that represent a portion of the negative. They are enlarged, but printed at almost the same size as one of Sander's contact prints.

HB: In portrait photography, and even in portrait painting, there were always certain compositional conventions—head, head and shoulders, down to the knee, the whole figure. Those were the basic possibilities; there wasn't much in between. If you cut a figure off in the middle, it would look like a tree trunk. You had to cut it off in a proportioned way. So Sander developed a style of portrait photography showing heads.

GC: But there is also the theory that he wanted to compare the faces.

HB: Yes, of course, he must have felt that these women had extraordinary faces, and that the face itself should be focused on.

SG: The question in physiognomic studies is whether you want the extraordinary face. Do you take Kant and try to figure out from his face why he's so smart? Or do you take typical faces and try to suggest broader categories? I tend to think of these images not in terms of the extraordinary, but in exactly the opposite way, that Sander wanted to document typologies. When we say that these are extraordinary faces, it aestheticizes them. I think the question is how rigid his physiognomic project was and whether or not he used any of the physiognomic systems that were floating around. Is this simply an empathetic organization, or is he using some "serious" classificatory system?

WN: Sander's methods do seem contradictory. On the one hand, he appears to be behaving totally from instinct and intuition; on the other, he sometimes seems to have a rigid system to which he adheres. My personal belief is that out of economic necessity he started photographing the people who were around him in the countryside, and that body of work grew to a point where he could look at it and say, "Hmm, there's something here that's quite interesting." Later on he reached a point where he could take two pictures such as these and make them seem as though they had some connection to a very systematic physiognomic structure. But the real motivation could be something unexpected.

My point here is that these two pictures are about the eyes of the subjects. Sander is trying to see into their inner beings through their eyes and also through the lines and shapes of their faces. I am trying to use these two pictures as evidence of the contradictory intellectual principles that may have been operating in his scheme of behavior.

UK: The typological portraits that these represent reflect a shift in his work, but how intentional a project is it? Around this time you could make money by circulating pictures of a physiognomic nature in Germany. Sander did this by going through older photographs and culling things that could be marketed. I can see your reading, which is very much an aesthetic one from a modern viewpoint; however, most Germans at the time would not have looked at these portraits in aesthetic terms, but in terms of groups to be excluded, of scary racial and physiognomic stereotypes. This gets us into very uncomfortable territory. The question is:

How naive was Sander in allowing these images to be used by others? You couldn't say that he used them; he just made money. But that is a very debatable act.

GC: I think that the encyclopedic idea is anchored in the nineteenth century, but in the 1920s and 1930s it became widespread, with a different attitude. In the 1800s it was still very scientific and straightforward and statistical, like the classification systems in biology and zoology. But in the 1920s it went in a mystical, magical, superstitious direction, with strange underlying ideas.

SG: These images can be read in a double sense. A physiognomist could read the ears of both these women as Darwin ears. They are without a distinct separate lobe and without a heavily delineated set of inner spaces. The Darwin ear was a sign of the degenerate. However, you can also consider these photographs in terms of mobile physiognomy, which has the notion of reading the experience in an aging face. It's important to think about these pictures not as something fixed, like the ears, even though the images may have been used in other contexts to illustrate this, but as an effort to show how a certain established sector of the population looked after it had aged and become experienced. Such a reading can be positive rather than negative.

JW: But that goes to the heart of the issue in many ways. It has to do with the intention of Sander's physiognomic project, if we can even call it that. After all, the notion of physiognomy runs through Sander's own comments on his work, particularly in his radio lectures. We should also keep in mind the reception of the images, which was dominated by a discussion of physiognomy, at least when it came to *Face of the Time.*

WN: I am uncomfortable with the idea that physiognomy was a first principle for Sander. One factor you have to consider here is whether the particular line of thinking that led to these portraits was a part of his internal exile. When he was no longer able to photograph, he started to go back through his own negatives and said: "Look what I've done, look what I've captured. I have all these different faces."

When I look through the firmly dated pictures from the teens through the late 1920s, I don't see the same obsession with line, facial shape, and the other classic physiognomic elements that we see here. They are buried deeply in the work, and

Sander had to hunt for them to bring them out. We don't really know when exactly he began to think about that part of his work.

UK: There is a consistent parallel here to the work of Lewis Hine, who before World War I photographed social problems in America. He then used some of the same pictures in the 1920s to show what was good about the country, and in the 1930s he used them again in different contexts. I think we have the same kind of thing going on with Sander—pictures that were done before World War I as client pictures became, in the early 1920s, "Citizens of the Twentieth Century." In the 1930s they became what was seen as proof of true Germanic stock.

DF: Let's move our discussion to another of Sander's well-known images, *Young Girl in a Carnival Wagon, Düren* (pl. 36) from 1929.

SG: One of the realities of collections of physiognomic images is that they were racial handbooks. Physiognomists talked about the unity of the Germans as opposed to the Jews and other marginal types, including circus performers. If the center is defined physiognomically, marginal types are quite often defined by context rather than by countenance. It was an obsessive sort of thing, but again, the question was how to describe differences not in terms of biology but in terms of sociology.

UK: This picture is a very good illustration of how Sander's photographs sometimes walk a fine line between formal portraiture and a distinct way of seeing. He was uncanny in never letting his images slip totally into anecdote. He always let people show who they were. He didn't make a snapshot of how he happened to find them, but said, "Now, show me . . ." It was a kind of conscious, distanced "alienation effect" of the kind introduced by Brecht in contemporary theater. *Snapshot* was a dirty word for Sander; his technique of using big cameras and exposure times of two or three seconds made snapshots impossible. There is a certain consciousness that comes from subjects thinking, "Well, it's going to be a two- or three-second exposure; I am supposed to collect myself and show something of myself."

HB: Yes, the slower exposure time guarantees that the subject performs a role, meaning that the picture comes closer to the personality than a snapshot.

WN: One of the issues that I see in this picture is the dichotomy between formalism and humanism that somehow seems to be present continuously in Sander's work. This photograph is one of the few examples in his entire oeuvre where he has accepted a situation that a classic formalist like Walker Evans would. I'm talking about the architectural backdrop to the image, the horizontal and vertical lines. But Sander did not feel compelled to place the camera completely perpendicular to the wagon, as Evans would have, so that the horizontal lines are perfectly horizontal. At the top edge there is a triangle that represents the degree to which he was out of alignment. He made a deliberate choice not to create a tight, irrevocable grid of the geometric elements. In fact, he was probably most intrigued by the painted ornamentation on the door itself, the free-form curvilinear shapes that are so much in contrast with the geometry of the architecture. He surely asked the girl to put her hand there in a very suggestive way, thereby making it, as it embraces that painted ornamentation, the entire subject of the photograph. In making that choice, Sander tells us that there is something mental and psychological about this work, that it is not purely formalistic. In this picture he is, in some ways, dissociating himself from canonical modernism, and yet we as observers and historians usually associate him with the modernist sensibility.

CB: Are you suggesting that this is an antimodernist statement?

WN: No, I am saying that structuralism, which is the heart of modernism, usually would respect the integrity of the structure. The one depicted here is composed of strictly horizontal and vertical lines. By choosing not to put the camera perpendicular to the surface, thereby causing the slightly oblique viewpoint, Sander has allowed himself to go out of sync with the background. You could say that because he usually included an amorphous, rather than a structured, background, he just didn't pay attention to it, but I don't buy that. He is too good a photographer; he's too observant and too aware.

SG: I would subscribe to everything you said, except that here I think the importance is first the circus wagon and then the girl. The wagon is the foreground; the girl is fitted into that, not the other way around.

WN: It's an ornamental surrounding of her; they're really on the same plane.

SG: They're on the same plane, but the carnival wagon gives meaning to the figure. This wagon is something anyone in the 1920s would have recognized immediately. Such painted vehicles were pulled through the countryside with "gypsies" in them, whether they were actually gypsies or circus folks or painters. These people were thought of as dangerous types. In the 1920s there were hundreds of images of circus performers done by the major Expressionists.

This is a very specific visual space, and it gives character to the person in it. Yet the girl's innocence belies the danger that these wagons imply.

CB: When I look at this, I am not reminded of Evans and modernism, but rather of an almost Surrealist notion. There are things that don't fit. I am thinking of the fragment of the girl, with only her arm coming out. The wagon is there, and then something appears in it that is unexpected. I wouldn't apply a formalist aesthetic, but rather a narrative one that places elements out of context and rearranges them in a way that makes us think about what we're seeing.

JW: I think you're absolutely right. But regarding the Expressionist connection with the circus, I think something different was going on here. The Expressionist artists identified themselves with the circus performers as bohemian outcasts. Sander's images seem to be about something else.

SG: I think the proof of your reading is that, with the Expressionists, all the circus performers were grotesques, and this is the antithesis of that. This is a "normal" little girl.

HB: Again, since Sander grew up in a society that was fairly diversified, he just saw these circus people as one group existing on the same level as other groups.

JW: What has always struck me is that Sander seems to have photographed circus people when they were not engaged in their profession. They are always shown behind the scenes, not during a performance (see pl. 37 and p. 129).

UK: This girl seems to be what in Germany would be called a *Schlüsselkind*, a child with a key. It's mostly a postwar phenomenon, when the parents were working, or maybe the father never came home from the war and the mother had to work.

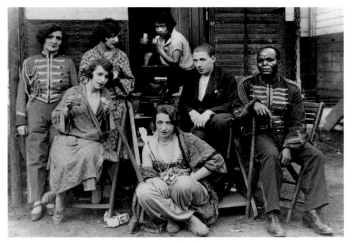

August Sander.
Group of Circus People, circa 1930–32.
Gelatin silver print, 19.9 × 27.5 cm.
84.XM.498.5.

JW: What we would call a latchkey child.

UK: Yes, that's it. You could pity these children because no one took care of them, and here you have the same sense. The girl is confined, but only because there is too much freedom in front of her.

WN: But it's partly because she looks so different from the circus performers Sander photographed, who look exactly like you expect circus people to look. Gabi, can you tell us something about the negative from which this print was made? What part of the negative does it represent?

GC: The full negative depicts a larger image and shows much more of the wagon. In this print Sander chose to make a tight cropping. The girl is shown close-up and is more related to the picture space than to the wagon.

DF: The next pair of portraits seems symbolic not only of Germany in the 1930s but also of Sander's role in that era. *SS Storm Trooper Chief* (pl. 42) was made in 1937; *Persecuted Jew* (pl. 44), about 1938.

CB: I would like to say something about the decision to place these images together. This was not done to create a facile juxtaposition of perpetrator and victim; what interests me here is what I would call the limits of physiognomy. We come to these pictures knowing that one is of a Nazi and the other of a Jew, but I want to look at how these people present themselves to the camera. We have talked about physiognomy, pose, and display in front of the lens, but I wonder whether we reach the limits here of being able to make those rather simplistic determinations of individuals.

WN: The question raised when we look at these pictures is why Sander photographed a Nazi officer. The same can be asked about the persecuted Jew, but it's much easier to begin to answer that question. I think the dichotomy is baffling for everyone concerned with Sander's body of work. From what we know about his politics and his life, why did he choose to put himself in the face of this man?

SG: What Sander does here is to pose the officer before the Cologne Cathedral, which is the one "German" building in Germany. It was completed because Bismarck, a Protestant, bought into the notion that there had to be one central site for German identity, and he didn't want it to be the church in Frankfurt where the revolution of 1848 came.

CB: There is another image in the collection (pl. 43) that shows a group of National Socialists and civilians at the train station in Cologne, and this man is in that picture. He must have requested to be photographed alone, or he was singled out. The station is right next to the cathedral, and he walked out onto the tracks to have his picture taken. If you walk out far enough, you get to a railing like this, with a clear view of the cathedral.

GC: I don't know specifically why this picture was made, but Sander was doing a project called "Cologne as It Was," and he was in contact with a lot of people. It could be possible that he met this group as a part of that project. It may have happened out of the situation.

WN: Do you think it's possible that the officer was an acquaintance of Sander's, perhaps an old school friend?

GC: No. What is important to understand is that Sander not only photographed the Nazis, he also had a category of soldiers in "Citizens of the Twentieth Century." This was an opportunity to depict another group of people, which was a normal response for him.

UK: This is a very good Nazi portrait because it's not satirical; it's not pointing a finger, which some of Sander's pictures do. It makes the image stronger that he doesn't take the simple way out, but it also deconstructs his own procedure, his tendency to say, "Okay, we'll add a few Nazis and a few victims, and otherwise German society is still the same." But it wasn't the same; by 1937 Germany had totally changed. He couldn't take pictures of the intellectuals, because they were in prison or had emigrated.

SG: If he actually saw this as an extension of his typology of the army, I think it indicates a level of self-deception that is frightening.

CB: When I was going through the Getty collection, I was fascinated by some images, dating from the mid-1930s to the early 1940s, of a man, his wife, and their child. Sander photographed them first in civilian clothes, and then in the next picture the man is wearing his uniform. To me, it showed some sense that this is the way it was. People at one moment were average citizens; the next, they were wearing a uniform. It was so seamlessly interwoven that I think they—if you can even speak of "average Germans"—didn't quite get it at the time.

WN: Is it correct that in 1937 the program of systematically exterminating the Jewish people was not yet in existence?

JW: Isolating and persecuting them, yes, but not exterminating them.

WN: What was reported in the newspapers and on the radio about these events? What did the general public know?

JW: It knew.

UK: It was a public intimidation campaign at that time, or even a little beyond that; there were some incarcerations, some beatings. It was a declaration of wanting to get the Jews out of Germany. Not to kill them, but to get them out.

WN: So to everybody in every community, certainly in Cologne, that public policy would have been as well known as any fact of the time.

UK: Absolutely.

WN: And we are sure there is no possibility that Sander was ignorant of what was going on.

DF: We can go a step beyond that. In 1937 he would have taken this picture knowing that the Nazis had already suppressed his work.

CB: And they'd arrested his son!

HB: How many years had his son been in prison by then?

GC: Three years. He was in prison from 1934 until his death in 1944.

HB: The arrest of his son could have been a reason behind this picture.

WN: Are you proposing that in some shrewd way Sander may have been trying to ingratiate himself with a political power that could have gotten his son released from prison?

HB: I am not saying that's so, and I don't know that.

JW: I have been reading about Sander being rather naive politically, and I wonder whether he fully grasped what the Nazis were capable of doing. At the same time, I've also been reading that he repeatedly had run-ins with officials and got into shouting matches with them. His wife was frequenting Jewish shops blatantly. It seems almost like he was challenging them, but in a way that suggests he didn't quite understand that these people would later systematically kill their opponents.

SG: The process toward the Final Solution in 1941 was very gradual. It wasn't something everybody knew in 1933. This period was really one of many stresses, and someone like Sander could indeed be oppositional without being in danger.

WN: But are you suggesting that Sander could have made this picture because he hadn't made up his own mind?

SG: No. I would agree with what Gabi said before. I think this was part of his typology. I think he was trying to accommodate portraits like this in a way that didn't contaminate his precepts.

HB: Like a Social Democrat!

SG: Absolutely. He did it in such a way as to say, "There are good Germans, and then there are these other guys." I think this is, again, a part of his bigger project. I also think it's a way out that a lot of Germans, both inside and outside of Germany, argued. They said, "A couple of guys came in and they screwed up the country. They weren't really Germans."

UK: Sander said that himself after the war. As he saw it, there were a few *Untermenschen*, subhumans, who caused Germany to be pushed out of the sun, and now it was time that the nation got back into it.

SG: Remember that many Jews in exile in the United States thought of themselves as being the "real Germany" and saw the Nazis as a disruption. In other words, it's not an atypical way of trying to organize what was going on. I think it was wrong, but it was not unique.

DF: How does the portrait of the Jewish woman fit into this context?

SG: The description of this is incredibly vague. Are there some of these images where it is clear—with a name or something—that a portrait like this belongs to the group of pictures of Jews?

UK: From looking through a lot of pictures, I can tell when I see this kind of face that it belongs in that group. In the collaboration between sitter and photographer, I think something happened where Sander, in subtle ways, got his subjects to have this sort of elegiac look. There is a sadness here, and it goes through the group. I think it's a signifier of victimization.

SG: I will mention something here that actually underlines what Ulrich said. Alfred Berndorfer, a Hungarian Jewish physician, wrote in 1979, reflecting on his experiences before 1945, that Jews in Europe developed a specific physiognomy, that

their anxiety was so great that it became part of the way that they were seen and saw themselves.

WN: There was a practical reason, as I understand it, for these portraits to be made —they were attached to the person's exit visa. It's a very functional photograph.

CB: What made this encounter possible was the woman's desire to get her passport picture taken. This is how she met Sander. And he then took that opportunity to make this photograph as part of his typology.

GC: This is what makes both of these images interesting for me. Sander had the same sense of objectivity toward the person, and he wanted to make the pictures because they fit into his projects. For him, this is the same thing that he did in the Westerwald.

UK: And it doesn't occur to him that there can't be order when such a conflict happens. It's very strange that he can, in a sense, normalize the Nazis. That's fair to say, isn't it?

JW: Maybe it's not surprising. Maybe in the complete breakdown, the arrest of his son, and the other things he observed around him it was an understandable reaction to want to hold on to some system of order and classification. He was desperately trying to make it work.

SG: But he did it by expanding the classification, which is peculiar. What the Jews have in common is not their estate, not where they function in society, but their common exclusion from the state. So again, Sander's is a classificatory system that is set up and then implodes; it collapses under its own weight.

WN: I'd like to think about some of the implications of this picture of a Nazi soldier, because to my eye we are seeing a man who is just as ennobled as was the peasant couple in the earlier picture (pl. 12). He is given such prominence in front of the Cologne Cathedral. Sander could have pointed the camera in a slightly different direction and eliminated the dignifying element of the cathedral. Somehow, of all the pictures that we've seen, this has the least trace of any element of satire. That troubles me, because I sense that Sander had an affinity for the officer that we are

not willing to admit—and it apparently is not documentable, according to Gabi. It seems like Sander has pointed his camera at him and said, "Here is a good man."

HB: Do you like him?

WN: I don't like him, no. But I think that Sander pointed his camera and said this in the same way that he pointed his camera at the Jewish woman and said, "Here is a good woman."

CB: I don't think he is making that comment in these pictures. I am reminded of Goethe's "gentle empiricism," a notion to which Sander subscribed—the idea of getting to the truth by very keen observation. It seems to me that Sander was striving toward a certain kind of objectivism, but I don't think he was trying to suggest a person was good or bad.

SG: It seems to me that this so-called scientific objectivity that Sander has as part of his project is something that is a carryover from the larger physiognomic movement of the teens and the 1920s—the idea of the observer as detached from the object. We can say that this objectivity is an illusion, but it's part of that notion of science. The idea of objectivity built into the Nazi image is very unpleasant for us, because we want Sander to say that this is a bad person, in which case we can say that Sander is a good guy, or that this is a good person, in which case Sander is a bad guy. But the difficulty of the classifications and of the pseudo-objectivity is that it is something that enables you to stand back. We could honestly say that is a problematic position, but it's one that becomes more problematic after 1933. It's unproblematic in 1931.

WN: Exactly. That's the issue.

DF: The final photograph we will look at is *August Sander's Studio/Home, Cologne: Workroom* (pl. 47), which was made sometime between 1930 and 1942. Perhaps we can begin by identifying the various objects in the image.

GC: The two pictures in the center are portraits of people important to Sander. Franz Wilhelm Seiwert is on the left; Heinrich Hoerle, on the right. Next to the door is a photograph that was done in a mine. You can see the workers filling an ore car. At the far right is an oil painting done by Seiwert called *Ländliche Familie*, done in

1923. Underneath this painting are two silhouettes. Sander was very interested in this medium; the one on the left is of his wife, Anna.

JW: And what is between the two photographs?

SG: They're graphic design tools—a T square and some triangles.

WN: This is one of a very extensive series of photographs that Sander made of his home and studio that really amounts to a self-portrait of himself and his family.

GC: He made similar pictures of his previous residences, so this was a typical approach for him.

JW: It would be wonderful to establish the date more precisely, because Seiwert died in 1933 and Hoerle in 1936.

GC: This portfolio was done during the time David mentioned, but I think it was more between 1938 and 1942. Part of Sander's motivation was to create a kind of inventory depicting the things he had. Although he was prepared for the war, a lot of his possessions were destroyed by it and its consequences.

JW: What is on the walls here is fascinating as an intellectual biography, the inspirations for Sander's life and work.

DF: Particularly the image of the mine. As autobiography, it is interesting that he displayed something that went so far back in his life.

CB: In a way, that sets the tone. The pictures in this series seem to culminate in this piece of autobiography. Once again, I detect a sense of melancholy here, a desire to excavate a life history from his current environment. It may have come at a time when he realized his friends had died, that this part of his existence was coming to an end. He was creating an inventory not only of his possessions but also of where he had been.

SG: Nobody has mentioned the junky nineteenth-century clock. It's a peasant clock, like you would find in every rural home. I think the mix of objects here is revealing.

CB: It represents a bit of what I perceive as an uneasy ideology. Here is someone who is basically of the nineteenth century, yet he's also of the twentieth. He is a con-

servative who is progressive. He is an innovator, yet he is a traditionalist. The old-fashioned stove and the cat give the whole thing a kind of homey intimacy, along with the clock, but the T square and triangles are symbolic of a more savvy technological outlook. The juxtapositions in this picture are stunning and seem to capture the many souls that resided in Sander and his work.

DF: To bring our discussion to an end, I'd like each of us to offer some final thoughts about Sander. While all of you have studied him in great detail, I began today with a good familiarity with his imagery but a very general knowledge of its context. I'm interested by how incredibly complicated the story gets when you consider the sociology and history that informs a body of work such as this. All artists are obviously "of their time," but Sander seems more a man of his time than many others.

JW: After this discussion, I am an even greater fan of Sander's work. I'm struck by the power of the images, but also by the ambiguities in them that elicited such different readings from us. I continue to be fascinated with Sander's physiognomic project; or maybe it's better to say that physiognomy serves as a kind of metaphor for his entire project. It points to the importance of classification for him, of putting everything in its place, of finding some certainty. The work we looked at testifies to his inability to do that, and to the futility of the project. I think that the failure of "Citizens of the Twentieth Century" is what makes it so significant. I think that's why it resonates with us so much today.

WN: Is it failure or incompletion?

JW: I think it's failure.

CB: Failure.

SG: Failure.

UK: Failure.

SG: One of the things that today's discussion—and Sander's photographs as an object of that discussion—has proven to me is that we need to go back and rethink German culture from 1919 to 1933 in complicated ways. A lot of the conceptual categories that we've worked with are exhausted. We have to go back and rethink cat-

egories such as conservative and progressive, such as the avant-garde. We have to rethink how we're going to use the culture of the 1920s in terms of arguments, for example, about continuities from the nineteenth century to the twentieth century, from 1933 to 1945, and after 1945. I think that Sander is more interesting because of the failure of his project, because this points out how we don't have a good vocabulary to talk about that failure in historical terms, in terms of Weimar.

HB: This conversation proves that the more one talks about Sander's photographs, the more enigmatic they become. We still can't explain what enabled him to make images of such universal metaphoric strength. However, we have figured out to some degree his motivation and the circumstances favoring his extraordinary encyclopedic work. First of all, his lifetime fell exactly into the golden age of professional portrait photography. When Sander learned his craft, it was at the peak of importance and perfection, after having taken over the tasks and aesthetic rules of portrait painting. Technically, the improvement of lenses, negative emulsions, and lighting allowed for moderate exposure times—seconds instead of minutes—ideal for portraits but not yet fast enough for action photography. The second reason has to do with the historical changes Sander witnessed, which we have talked about at length. This must have been an exciting moment for him to make his decision about an encyclopedic enterprise, since he had already accumulated a lot of material.

For me, the mystery of these deeply convincing results lies in the fact that Sander accepted the self-interpretation of his sitters, their chosen role in life, instead of trying to define their "character." This way, paradoxically, the photographs come closer to the truth.

CB: I feel a greater sense of confusion now than when we began, and that motivates me to keep on pushing some of the categories that we talked about. I agree with Joan that through the failure we may learn a lot more about the man than we probably could if everything fell neatly into place. The inconsistencies and contradictions in his enterprise continue to mystify and intrigue us. It also seems to me that the state of research on Sander has some serious holes in it, which this conversation really highlighted. We're all very imaginative when it comes to contextual constructs, all of which I think are legitimate and valid, but the man himself seems to remain an enigma, which is challenging and keeps us looking for answers.

GC: What was interesting for me was to see all the different positions in regard to Sander; I learned a lot from this discussion. And I enjoyed it, even though the sequence of pictures we saw was not representative of his photographic oeuvre and his various projects. What this indicates to me is that Sander is confirmed by his method, which is open and which cannot be understood as a statistical approach. I don't see it as a failure that he didn't finish "Citizens of the Twentieth Century." For me, it is a very modern view of things; nowadays we would call it a "work in progress." It is a realization that reality cannot be fixed.

UK: I should begin by expressing my profound gratitude for all the interesting facts I've learned; it is wonderful to be surrounded by people who, from their various perspectives, have said so many fascinating things. When you have written a book, and it's now almost a quarter of a century since my book on Sander was published, it's always a bit sad when you later come to know all the information you could have put in the book and didn't! Of course, some of these details simply were not accessible then, because the sources were not yet there to be used. It's great that our knowledge, and therefore the increased possibility of understanding Sander better, has grown so much.

WN: Today I come away with a very enriched sense of the one and only thread that Sander and I share: we are both collectors. He did his collecting with the camera, much in the same way that I have gathered pictures in the Getty Museum's collection. I identify with the process that he had to go through in picking and choosing not only his original subject but also deciding when to use the photograph. So I see a kind of continuity with the photographer as a collector.

Maybe the last word today should go not to me, but to Alfred Döblin, who wrote the preface, short as it was, to Sander's first book. Döblin said about the photographs: "You have in front of you a kind of cultural history; better, a sociology that will last thirty years. How to write sociology without writing, but presenting photographs, and instead photographs of faces and not meshing costumes. This is what the photographer accomplished with his eyes, his mind, his observation, his knowledge, and last but not least his considerable photographic memory. Thank you, August Sander, for what you gave us."

Thank you all for giving us so much of your collective wisdom.

Chronology

1876

Sander is born on November 17 in Herdorf, a small village east of Cologne, Germany. He is one of eight children of August Sander (1846–1906), a mining carpenter, and Justine Jung Sander (1845–1919), the descendant of a long line of local peasants.

1882–96

Attends the Protestant public school in Herdorf until 1890, when he begins work at the local San Fernando iron ore mine. Meets the photographer Heinrich Schmeck in 1892 and becomes interested in photography. The same year, purchases his first camera with the help of his uncle Daniel Jung and sets up a small darkroom.

1897–1900

Serves in the Wilhelmine military in Trier. When off duty, helps out in the studio of the photographer Georg Jung. After completing his stint of service in 1899, travels as a photographic apprentice to Berlin, Magdeburg, Halle, Leipzig, and Dresden, where he is said to have audited classes in painting at the Royal Academy of Art or the Dresden Academy of Applied Arts.

1901

Accepts his first professional assignment, at the Greif Photographic Studio in Linz, Austria, where he teaches himself the vocabulary of pictorialism and becomes a first-rate art photographer.

1902

Marries Anna Seitenmacher of Trier on September 15. Enters into a partnership with Franz Stuckenberg to direct the Greif Photographic Studio, renaming it Sander and Stuckenberg.

1903

Receives the bronze medal at the Upper Austrian Regional Exhibition in Linz for his photographs and paintings. A son, Erich, is born.

1904

Disagreements with Stuckenberg lead to the dissolution of the partnership; Sander becomes the sole proprietor of the business. He is awarded the Müller and Wetzig Prize at the Leipzig Book Fair, a gold medal at Wels, Austria, and the first prize and Cross of Honor at the International Exhibition of Decorative Arts at the Grand Palais in Paris. Experiments with color photography.

1906

Is awarded fourth prize in an international portrait competition organized by the Knapp publishing house in Halle. In his first solo exhibition, shows one hundred large-scale prints at the Landhaus Pavillon in Linz to great critical acclaim.

1907

A second son, Gunther, is born.

1909

Participates in the Art and Craft Exhibition in Linz, winning the silver medal. A polio epidemic breaks out; Erich contracts the disease. On the advice of the family doctor, Sander sends his wife and children back to Trier. He decides to sell his business in Linz and move the family to Cologne.

1910

After a brief stint as the business manager of the portrait studio of Blumenberg and Herrmann, Sander opens his own portrait studio in Cologne-Lindenthal. Because

business is initially slow, he frequently visits the farms of the nearby Westerwald in search of new clients. Begins to practice what he calls "exact photography," breaking with the tenets of Pictorialism.

1911

Twins, Helmut and Sigrid, are born; Helmut dies shortly after birth. Moves family to another apartment with a studio at Dürenerstrasse 201.

1914

Exhibits his work at the Berlin Museum of Arts and Crafts and the Werkbund in Cologne. After the outbreak of World War I, serves in the medical corps on the battlefields in Belgium and France. During his absence, Anna runs the studio, taking portrait photographs of soldiers.

1918

Returns home to Cologne and continues his portrait work in the Westerwald.

1919

On July 31, the National Assembly proclaims the Weimar Republic a constitutional democracy. The Weimar Constitution becomes law on August 14.

1920–25

Connects with a group of contemporary painters, the Cologne Progressives, forming close friendships with Heinrich Hoerle and Franz Wilhelm Seiwert, the chief theoretician of the group. Develops plans for a documentary project entitled "Citizens of the Twentieth Century," a series of about 540 portraits divided into seven groups according to the existing social order, with about forty-five portfolios of twelve photographs each. Completes the first folio, focusing on the farmer as the human archetype.

Franz Wilhelm Seiwert. *Wet Stamp for August Sander,* designed circa 1927. 5 × 5.6 cm. 84.XM.126.412.

1926

Meets Ludwig Mathar, the author of a book on Italy and several works of fiction. The two plan a volume on Sardinia.

1927

Spends three months in Sardinia with Mathar, returning with over five hundred negatives. The two publish a short article with Sander's photographs as illustrations to Mathar's text. Exhibits about one hundred prints at the Cologne Kunstverein as a preview of "Citizens of the Twentieth Century."

1928

Art Forms in Nature (*Urformen der Kunst*) by Karl Blossfeldt (1865–1932) and *The World Is Beautiful* (*Die Welt ist schön*) by Albert Renger-Patzsch (1897–1966), two milestones in the history of German photography, are published.

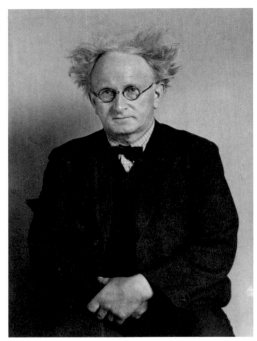

Unknown German Photographer.
Portrait of August Sander after His Nap, circa 1936.
Gelatin silver print,
23.1 × 16.4 cm. 84.XM.126.72.

1929

The year of the Wall Street crash and the ensuing world economic crisis, Sander publishes *Face of the Time,* a book of sixty photographs, at the Kurt Wolff/Transmare Verlag in Munich. The novelist Alfred Döblin writes the introduction. Thomas Mann (1875–1955), winner of the year's Nobel Prize in literature, calls the collection of portraits "a treasure-trove for lovers of physiognomy and an outstanding opportunity for the study of human types as stamped by profession and social class."

1931

Delivers five radio lectures on the "Nature and Development of Photography" in Cologne. He is at the pinnacle of his career.

1933–34

On January 30, 1933, President Hindenburg names Adolf Hitler chancellor, and the National Socialists assume power in Germany. Sander creates and publishes five folios in the series *German Lands German People (Deutsche Lande Deutsche Menschen),* each introducing a different region of

Germany and reflecting various themes: portraits, architecture, landscape, and botanical studies. His son Erich, a member of the German Communist Party, is arrested by the Gestapo and sentenced to ten years in prison. Sander, having assisted Erich in the reproduction of Communist leaflets, remains under Nazi suspicion.

1936

The Reich Chamber of Visual Arts orders the publisher's halftone plates for *Face of the Time* destroyed and all available copies of the book confiscated. Sander is forced into internal exile, increasingly focusing his creative energies on landscape photography and botanical studies.

1939

On September 1, World War II breaks out. Sander stores about forty thousand negatives in the basement of his Cologne house to protect them from damage. He begins to move his studio to Kuchhausen, a small village in the Westerwald.

1944

Erich dies in prison shortly before his scheduled release, the cause of death listed as "unknown." After the Cologne apartment is destroyed during a bombing raid, Sander moves permanently to Kuchhausen, taking with him ten thousand of the forty thousand negatives preserved in the basement.

1945

The end of World War II leaves Germany a divided country.

1946

A fire in the Cologne basement destroys the remaining thirty thousand negatives. The move to Kuchhausen severely curtails Sander's living and working conditions and basically ends his career as a commercial photographer. He resumes work on "Citizens of the Twentieth Century," sorting through the remnants of his archives, arranging and rearranging old material for the remainder of his career.

1951

Sander's work is included in the First Photokina exhibition in Cologne.

1953

The City of Cologne buys Sander's portfolio "Cologne as It Was" ("Köln wie es war"), a survey of historic Cologne executed before the war.

1955

Sander's work is included in Edward Steichen's *Family of Man* exhibition in New York.

1957

Anna Sander dies.

1958

Becomes an honorary citizen of his hometown, Herdorf.

1959

A special edition of the art magazine *DU* contains an appreciation of Sander's work, with essays by Golo Mann, Manuel Gasser, and Alfred Döblin.

1960–61

Receives the Cross of Merit and Cultural Prize of the German Photographic Society.

1962

The portrait album *Mirror of the Germans* is published, presenting eighty of Sander's pictures. His work is shown in Mexico.

1964

Dies on April 20 in Cologne.

August Sander.
*August Sander's Studio/Home, Cologne: Laboratory, Drying Corner,
and Enlarger* (detail), circa 1930–42.
Gelatin silver print, 22.5 × 16.7 cm. 84.XM.152.183.

Editor	Gregory A. Dobie
Designer	Jeffrey Cohen
Production Coordinator	Stacy Miyagawa
Photographers	Charles Passela
	Ellen M. Rosenbery
Printer	Gardner Lithograph
	Buena Park, California
Bindery	Roswell Bookbinding
	Phoenix, Arizona